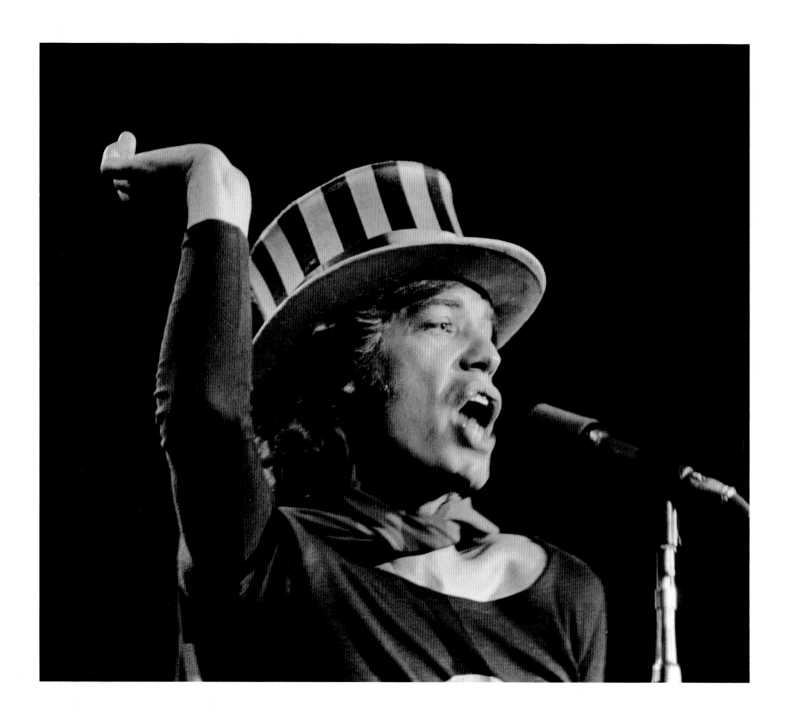

CLASSIC ROCK

&

OTHER ROLLERS

BARON WOLMAN

PREFACE BY JANN WENNER

SQUAREBOOKS

SQUAREBOOKS

P.O. Box 6699
Santa Rosa, CA 95406

P.O. Box 1000
Mill Valley, CA 94942

1 2 3 4 5 6 7 8 9 0

ISBN: 0-916290-54-9 (softbound edition)
Book design by Lauren Kahn
Production: Christienne de Tournay
Hand-Colored Photos by Ann Rhoney
Printed in Hong Kong

COLLECTORS:

Squarebooks has produced a hardbound edition of CLASSIC ROCK & OTHER ROLLERS. It is available only from Squarebooks and in limited numbers. Limited edition photo portfolios are also available. Each portfolio contains 12 custom enlargements. Each series is signed and numbered, and limited to 100 copies. Individual black & white and color prints can be ordered, too. Write for information.

WITH MUCH APPRECIATION *to Jann Wenner, Bill Graham (1931-1991), and San Francisco. Without Jann there would have been no Rolling Stone. Without Bill there would have been fewer musicians to photograph. And without the good fortune of the three of us finding ourselves in San Francisco in the milestone Sixties, this book would not exist. I'm sure glad it happened.*

— baron wolman

PREFACE

I N THE early days *Rolling Stone* was very much a part of the San Francisco rock movement. Those were different times, when everyone knew everyone else, when we were all discovering the power of music, and shaping ourselves into the "rock and roll scene."

Although the Stones and Beatles were gods who were far away, other bands elsewhere in the United States just did not mean as much to us as those we lived with, heard play every weekend and knew in San Francisco. The Dead, the Airplane, Quicksilver, Big Brother — they were the bands we saw in clubs and ballrooms, celebrated with when they got their first recording contracts and stood by as their careers took off.

Back then musicians traveling through San Francisco were also far more relaxed and accessible than they are today. Our reporters, Baron, sometimes myself, had no trouble going backstage or hanging out before or after the shows.

One night Pete Townshend came over to my house after a concert. We did the *Rolling Stone Interview* until the early hours of the morning. It turned out to be a significant interview in that it was the first time Townshend formulated and articulated his plans for what later became *Tommy*. Earlier that night Baron shot one of my all-time favorite pictures of Pete, on the Cow Palace stage with his arms fixed straight out, dressed in a glorious, sparkling jacket, staring right at you.

The first "celebrity visitor" to *Rolling Stone* was Stevie Winwood. Traffic was playing somewhere in San Francisco. I had been a fan of Winwood's since the first Spencer Davis record, so I was having a terrific time running around the city with Stevie and Chris Wood. (In fact, Al Kooper was in town that week and he wrote the Traffic article for us.)

In any case, Winwood came to our office, a printer's loft we shared with a dozen hot Linotype machines which clanked all day long and smelled of burning ink. The operators were some of the crustiest union guys I had ever run into. A few had taken to throwing a slug of type in my general direction every time they had to set the word "fuck," so they were none too pleased when I took the slender, ethereal Winwood, with his long scarves, on a tour of their operation. But Stevie won them over.

Baron Wolman is one of the unsung heroes of the early days of *Rolling Stone*. As the magazine's first photographer, he helped set its visual style and paved the way for those who followed him. Since I always envisioned *Rolling Stone* as a newspaper with an elegant magazine look, it was important that the photography, one of its main components, reflected this. Baron brought his craftsmanship and his sense of clarity to the graphics side of *Rolling Stone*. I wanted a classic feel and Baron knew how to do that, and together with our art director, Robert Kingsbury, we achieved a unique design spirit that remains with us today.

With all the fame and glamour accrued to *Rolling Stone* in recent years — and to the magazine's principal photographers, Annie Leibovitz, Richard Avedon and Herb Ritts — we should not overlook one individual who paved the way for rock and roll photography. It is with gratitude and respect that I introduce you to Baron's CLASSIC ROCK & OTHER ROLLERS, a treasury of images from the early years of rock and roll and *Rolling Stone*. This book tells the tale of those great days of discovery.

— Jann Wenner
New York City, April 1992

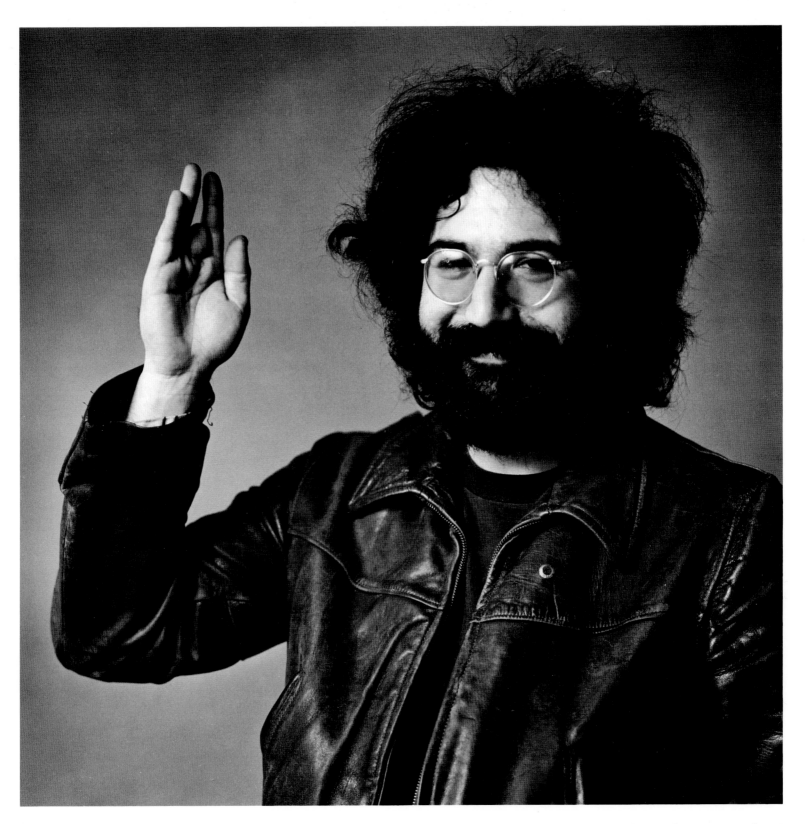

JERRY GARCIA *The Grateful Dead, Belvedere St. studio, San Francisco, July 1969*

I SAW THE MUSIC

We were there. In San Francisco, at Woodstock, at Altamont, for the first issue of Rolling Stone, *for the political demonstrations, and on Haight Street during the Summer of Love.*

It was a time of new fashion and new ideas, of enlightened innocence. Beyond that, it was a time when music, rock and roll in particular, emerged to become both the messenger and the message, grew to become the enormously photogenic entertainment of the People. How things looked and sounded suddenly became metaphors for shifting attitudes. Our hair grew long. Our clothes became more colorful, less predictable. Music lyrics reflected our growing discomfort with the state of the nation and urged America to consider new paths toward equity and enlightenment.

When Jann Wenner outlined his idea for Rolling Stone, *and suggested I be the photographer, it was a natural, a chance to expose the world to what was to become cumulatively the biggest political, sociological, sexual and musical revolution of the twentieth century.*

On October 18, 1967, Rolling Stone *published issue Number One. Wenner's dream had become reality, gone from a notion to a newspaper, and we celebrated with champagne. For three glorious years music and pictures were my life. Jann sent me back and forth across the country, accompanying writers, to shoot live concerts and still portraits. It was thrilling.*

This, then, is my photo album, a scrapbook of mostly music memories from the late Sixties and early Seventies.

M Y VERY FIRST *Rolling Stone* assignment was to photograph the Grateful Dead following the October "marijuana raid" on their San Francisco Haight-Ashbury house. That informal portrait of the band on the front steps of 710 Ashbury Street was the best shot from an entire roll of the Dead cutting up for the camera, flipping me the bird and pointing rifles in my direction. Carefully posed pictures were a total impossibility.

Janis Joplin was one of my favorite subjects. She, too, lived in the Haight. I made portraits at her apartment, at my studio and at a friend's house. At her place she stood in front of a wall covered with Janis Joplin posters, lounged on her bed with her cat, then wrapped in herself in her trademark sequined black cape (sadly, it was later stolen at a concert). In my home studio we set up the lights and background to simulate a live concert. Janis brought a recently recorded demo tape with her that we played on my cheap little portable deck. With considerable intensity and emotion she sang along as I made the pictures. The old wooden house resonated with the sound of her voice. Downstairs my wife was moved to tears by the power and beauty of the music.

That Grace Slick was gorgeous was reason enough to photograph her. To good looks, add her considerable imagination. Since she often appeared in an old Girl Scout uniform, I suggested she wear it, which she did, then proceeded to recite the Scout's Honor into a make-up mirror.

Before the administration of *Rolling Stone* became full-time for Jann he would occasionally write a story or do an interview himself. For a piece on the elusive and reclusive record producer Phil Spector we flew down to Los Angeles late one afternoon in January of 1969. On instructions from Spector, we parked our rented car in front of his office on the Sunset Strip where we were to be met by a driver. At the designated time and place a limousine with darkened windows circled by once, then pulled up behind us. We climbed in and were driven (circuitously?) to Spector's nearby hillside home. I vaguely recall an electric driveway gate and perimeter security fencing, even a heavy metal gate covering the front of the mini-mansion.

We were escorted into the house by Spector's chauffeur-bodyguard guard who quickly doffed his coat to reveal a shoulder holster and gun. While Spector was "getting ready" we amused ourselves for a half-hour touring what Jann later described as "Phil Spectorland, with framed pictures and clippings, all the famous articles about Phil, and jukeboxes with his hits still on the playlist."

The intrigue ends there. Spector turned out to be a gracious host, the interview proceeded without incident, and he even changed clothes once for the pictures. Yet, on the late-night flight back to San Francisco I felt as if I had been in a scene from "The Twilight Zone."

If I were to pick the date when my photographic love affair with music and musicians began it would be in Oakland at the March 1967 weekend of the Mills College Conference on Rock and Roll. That gathering was also the event that brought me together with Wenner. I was a thirty-year-old freelance pho-tographer looking for a writer to cover the conference with me; Jann was twenty-one and writing about music for the *Sunday Ramparts*, a weekly newspaper published in San Francisco by the staff of the monthly *Ramparts* magazine. Among others, the conference panelists included Phil Spector, concert promoter Bill Graham, and music critic Ralph J. Gleason. While the Jefferson Airplane played, a liquid light show sparkled behind them. Although today I barely remember a single topic discussed over that weekend, this event confirmed what I already knew intuitively—that rock and roll was here to stay, that it now had political and social significance and was about to grow far beyond the music itself.

From that very first issue late in 1967, *Rolling Stone* appeared regularly, twice a month, pretty much without interruption. By then Graham was presenting concerts in his Fillmore Auditorium every weekend. San Francisco quickly became an American music crossroads. Graham booked in musicians from around the country and around the world; it was a feast for those of us who loved to listen and dance, and photograph.

In November 1967 The Who (plus The Association, Eric Burdon & The Animals, The Everly Brothers, The Sopwith Camel and The Sunshine Company) played the Cow Palace in San Francisco. Peter Townshend was dressed in his appropri-ately flamboyant signature outfit (soon to be discarded—he complained pieces were too often stolen by souvenir hunters) and he performed his signature guitar-destruction onstage (soon to be discarded as incidental to the music). The picture of musician-evangelist Townshend, arms overhead, spread wing-like to the audience, was shot that night.

Early in 1968 the Jimi Hendrix Experience came to town. Jimi's career had yet to go super-nova but it was clear that recognition of his enormous talent was near. In his hotel room at Fisherman's Wharf I photographed a surprisingly pensive, quiet young man.

Quiet his concert was not. For this show at the original Fillmore Auditorium on Geary Street, I was onstage, crouched to one side, next to the powerful Marshall amplifiers. A light show lit up the screen behind Hendrix. Soon, in one of those difficult to explain, magical moments, I started to feel as if the music and I were one. My body began literally to resonate to the sound, my brain seemed to anticipate the moves of Jimi's body as he alternately attacked and caressed his guitar.

In my mind Hendrix was playing the guitar and I was accompanying him with my camera. I went on to shoot many more live performances, but it never got any better than that February night at the Fillmore. I made this book's cover photograph at that concert.

For me, the camera *was* the instrument and I was the player. Back then, before MTV, before video music, playing my camera, I stretched for the ultimate visual harmony: that single picture which might bring the essence of a concert to the printed page. I heard the sound, but I reached to see the music.

Of course, you can't photograph the music, only the musician, a fact not lost on me or the music makers. While many appeared to enjoy hamming it up for the camera, I was never sure whether they liked having their pictures taken.

Flashing a scowl, Frank Zappa happily clambered over construction equipment behind his Laurel Canyon home. Booker-T (of the MG's) Jones immersed himself fully dressed in Jann's Portrero Hill hot tub (empty). Steve Winwood toured the *Rolling Stone* production room and Gregg Allman bared his midriff in a Macon, Georgia, recording studio.

Many others were clearly uncomfortable posing, insisting that what mattered was the sound, not the look. However, years later Mick Jagger acknowledged what is now considered an industry truth: "That's what the music business is like — what you wear, how you look."

Over the years a dichotomy between the music and the music business developed. As the music became more popular, the music business became bigger, much bigger. Photographers were soon reduced to mere adjuncts of the business of music, tolerated much like remora fish, necessary parasites. Even some musicians grew impatient. At her concerts, Joan Baez would limit picture-taking to the first two songs. "Make all the noise you want," she commanded. But after that short photo opportunity, shoot a picture and you were tossed out. In all fairness to Baez, a hundred Nikon shutters did not harmonize with her delicate voice and acoustic guitar.

I had less of a problem than most photographers. Soon enough, music people came to understand that the *Rolling Stone* photographer was not the personal photographer of The Rolling Stones, and I gained "access" with considerable ease. Access was the key: to backstage, to recording studios, to the musicians themselves. Without access a photographer simply stood mashed in the crowd and hoped for the best.

As the music grew in popularity and the concerts in size, the backstage scene experienced its own revolution. Rather than puzzle over the exercise in excess it was to become, I affectionately recall those early backstage gatherings, remem-

ber relaxing on the ancient, ever-present, overstuffed couches. Band members and their friends came and went as sets began and ended. Groupies eased close to their favorite musicians; reporters stopped for a quick interview. The air was always sweet with smoke and camaraderie.

With acknowledgment to time, which tends to sanitize memories, I recall the days at *Rolling Stone* as being similarly sweet. Jann had correctly identified music as an emerging, pervasive passion, much more than entertainment alone. We were charting new waters in popular journalism, both in subject matter and approach. We were brash (I was the conservative one), we were willing to take risks to reflect an emerging and changing lifestyle.

We were on to something and we knew it. The creatively crazy energy around the office was infectious. I came away from editorial meetings crackling like a sparkler, bouncing off every wall; anything and everything was possible.

My home was a five-minute walk from the corner of Haight and Ashbury streets, five minutes from Golden Gate Park, five minutes from the head shops and the free concerts. Two upstairs bedrooms had been converted into a little studio and a darkroom installed in the basement. A steady stream of "rockers & other rollers" visited that Belvedere Street house. Kids in the neighborhood wondered aloud about the black limousines that regularly deposited musicians at my door.

When musicians couldn't come to my place, I went to theirs, or took them on location. I easily convinced B.B. King to stand in front of a replica of Rodin's *Thinker*, suggested that Miles Davis pose at home in front of his own painting, and brought a bouquet of daisies to TinyTim. For an informal portrait, Donovan (quite rightly) declined to change into designer clothes sent along by *Vogue*. Rick Nelson's twin sons never quite stopped crying, and Booker-T sat in an MG.

Those of us with stimulents were generous; sharing was the only accepted behavior. While I was drawn to the hospitality, I allowed myself only an occasional high. Cameras had not yet been taught to focus themselves and I didn't want to miss a single picture. Now and then, a delightfully mysterious substance might appear in an otherwise ordinary dessert; and nobody could emerge from the confines of a three-hour concert with his senses entirely intact.

As Jann would later scribble on the wall, "nothing is forever." *Rolling Stone* moved to New York and I moved on: to a magazine of my own, to a small book-publishing company of my own, to an airplane of my own.

Yet, maybe some things don't change. These photographs haven't faded, I'm still on a natural high, the memories persist, and this truth remains: Life would have been a whole lot tougher without rock and roll ...

— *baron wolman*

MUSIC 1967

SAN FRANCISCO was alive with music. All around the Bay Area, in head shops and boutiques, on telephone poles and fences, endlessly original, colorful posters announced the coming attractions. ● Weekend was concert time. At Bill Graham's Fillmore Auditorium or at the Family Dog's Avalon Ballroom we gathered to listen and dance and dream. It was comforting, it was elevating, it was inspiring. Music was the entertainment of choice and it gave us hope. ● Free concerts had become memories as music and business struggled to co-exist. Promoter Graham produced wonderfully organized and professional shows; businessman Graham noted correctly, if simplistically, that even musicians have to eat. A "free" concert in San Francisco's Cow Palace was sponsored by White Front Stores (a K-Mart look-alike), MGM and Warner Brothers records. The concert, which featured The Who, was indeed free—if you first bought a stereo album on a sponsor's label from a White Front store. ● The Grateful Dead and Mike Bloomfield's band, The Electric Flag, were busted on narcotics charges in the same week of October. At a press conference in the Dead house at 710 Ashbury Street, manager Danny Rifkin claimed, "If the lawyers, doctors, advertising men, teachers and political office holders who use marijuana were arrested today, the law might well be off the books before Thanksgiving." ● The first issue of *Rolling Stone* noted that "Otis Redding dethrones Elvis Presley as top male vocalist in the annual poll of the London *Melody Maker*." Two months later Redding died in a plane crash. ● In California, Johnny Cash explained, "Country music is slow to jump on any trend, but we've been affected greatly by the sounds of the Beatles and the lyrics of Bob Dylan." In Denver, a Donovan concert was canceled; even reduced to $2.50 each, the tickets didn't sell well enough to justify opening the doors. Ike was still with Tina Turner when they played San Francisco's hungry-i. In that intimate basement club, the stage was no more than five feet from the front row of tables. Electric Tina, in perpetual motion, was clothed in a silver mini-skirt. The Ikettes gyrated on her left, as Ike strummed sullenly in the background, occasionally coming forward to add a quick vocal. Tina Turner would not play clubs forever. ● By year's end *Rolling Stone* had published three issues, Bob Dylan was in Nashville recording again, and San Francisco's Steve Miller Band and the Quicksilver Messenger Service had each signed $50,000 record deals with Capitol Records. ● It was amazing how quickly music had moved to the forefront of our consciousness and become an integral part of our lives. What had begun only a few months earlier as small, informal and free gatherings, often in and around Golden Gate Park, suddenly bloomed into regular, organized events. The fun had begun.

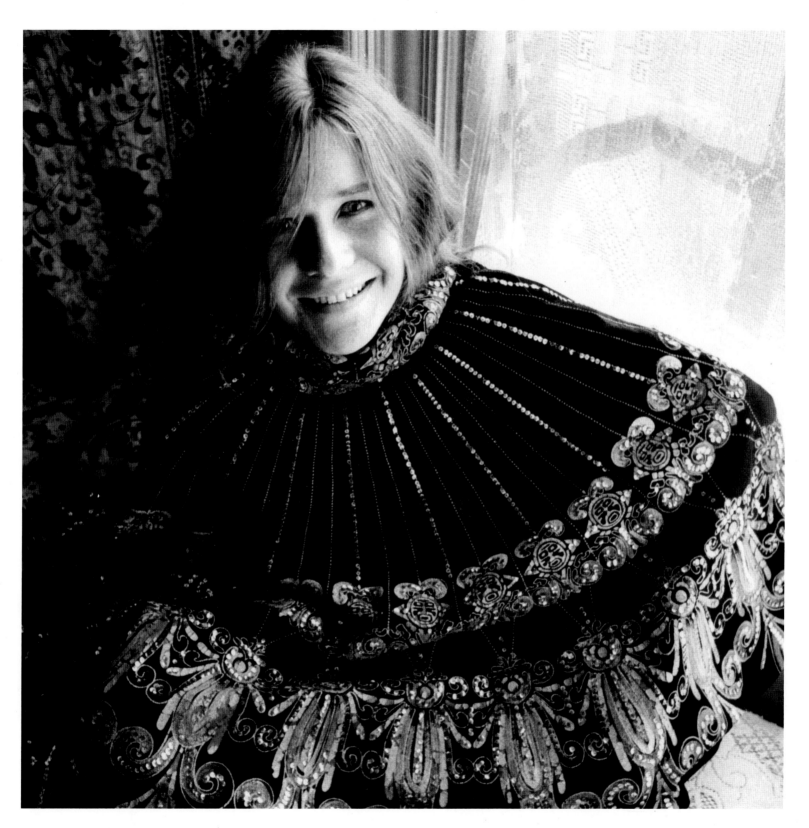

JANIS JOPLIN *At home in the Haight-Ashbury, San Francisco, Nov 1967*

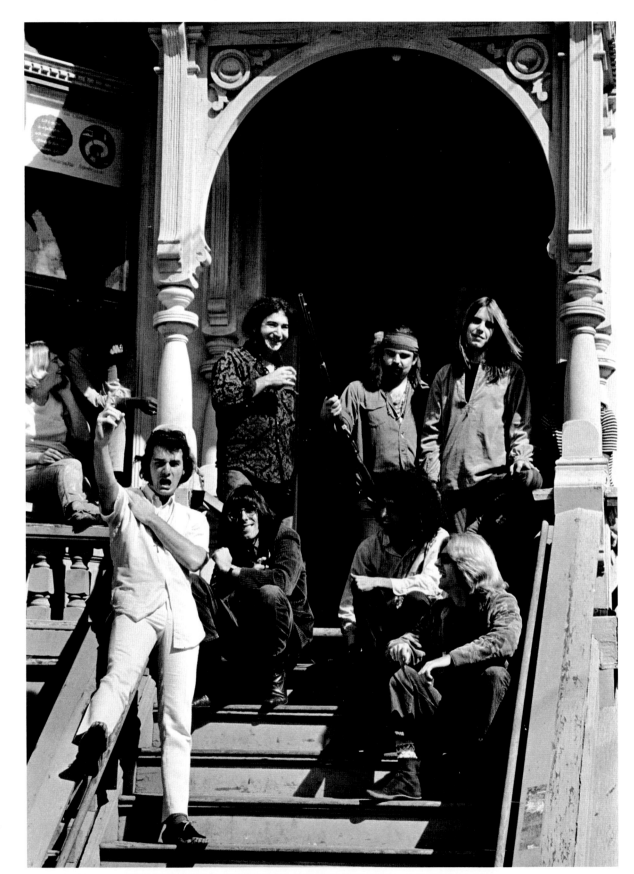

THE GRATEFUL DEAD
710 Ashbury St.
San Francisco, Oct 1967

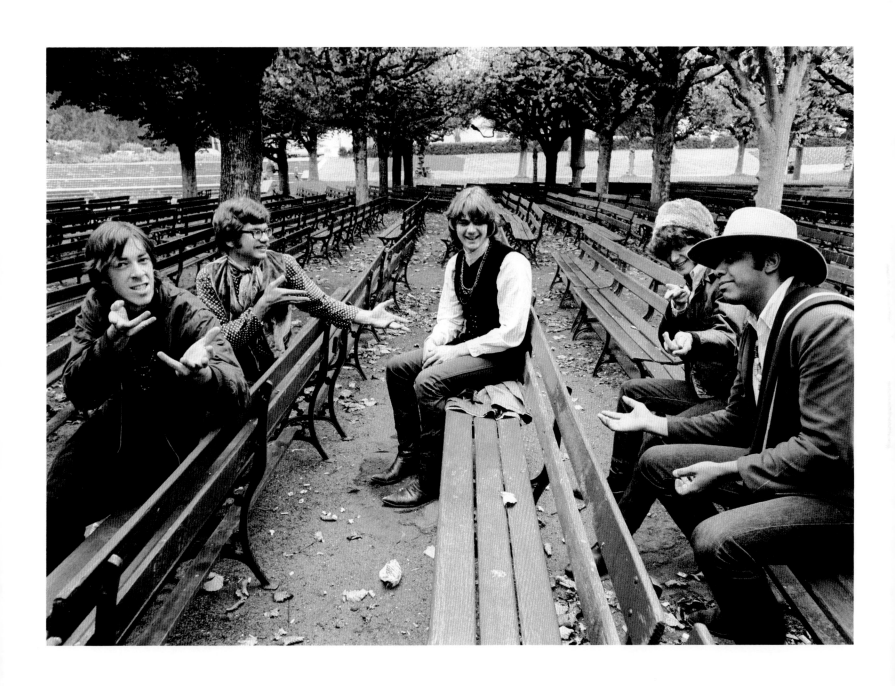

THE STEVE MILLER BAND *Golden Gate Park, San Francisco, Nov 1967*

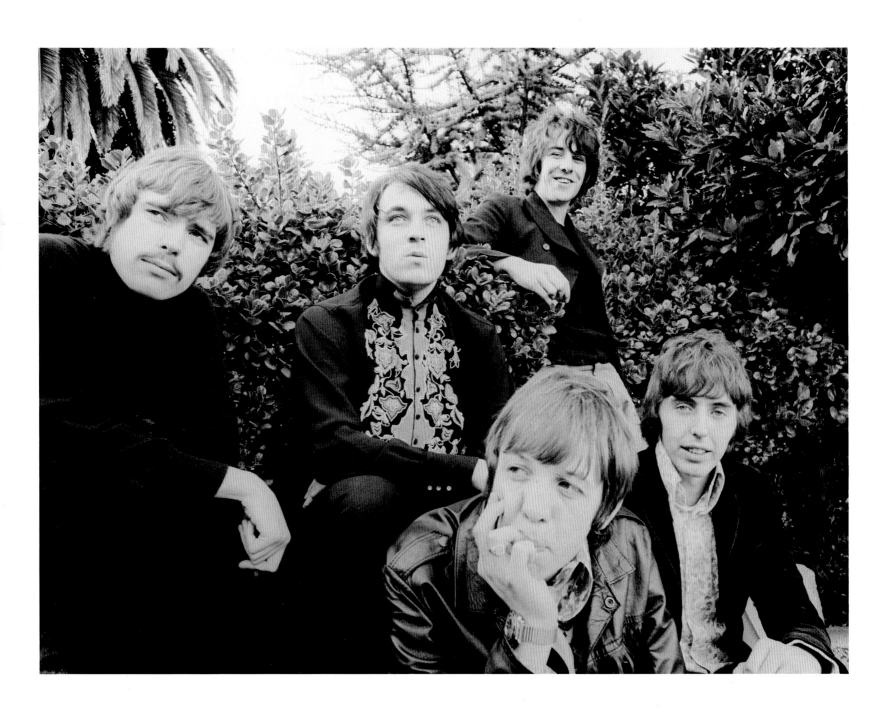

PROCOL HARUM *Sausalito, Nov 1967*

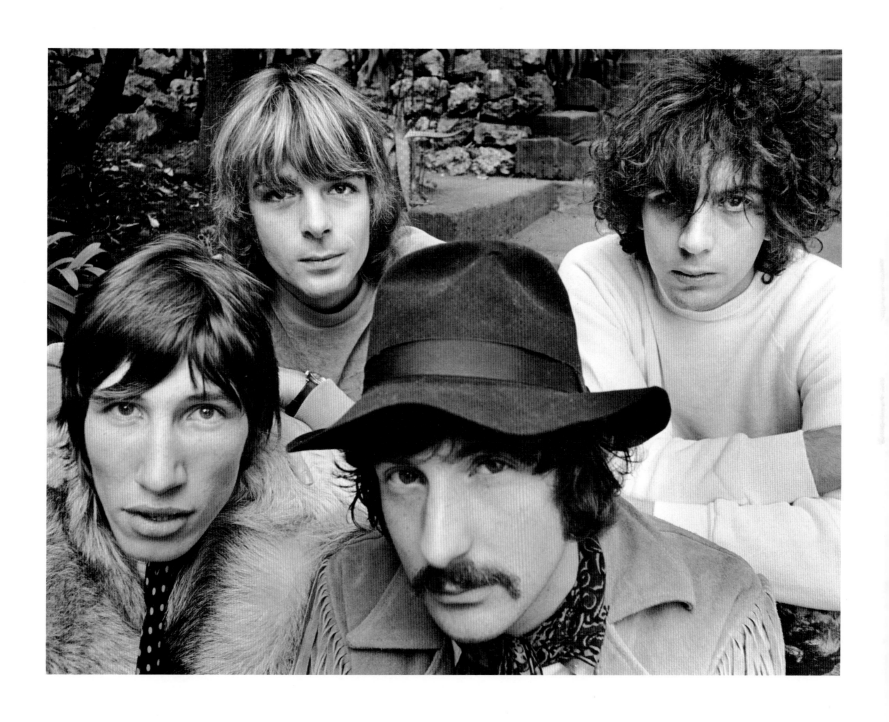

PINK FLOYD *Casa Madrona Hotel, Sausalito, Nov 1967*

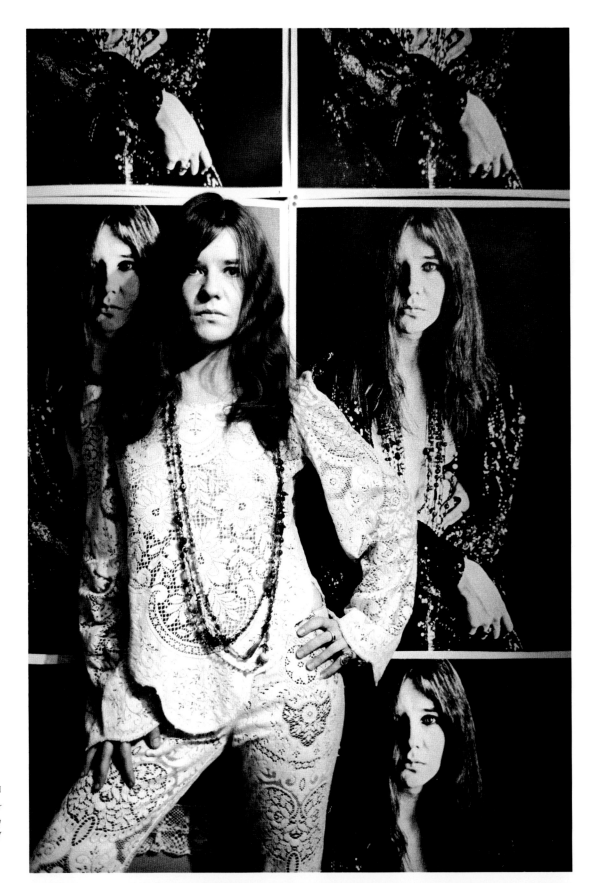

JANIS JOPLIN
With Bob Seidemann Poster
At home in the Haight-Ashbury
Nov 1967

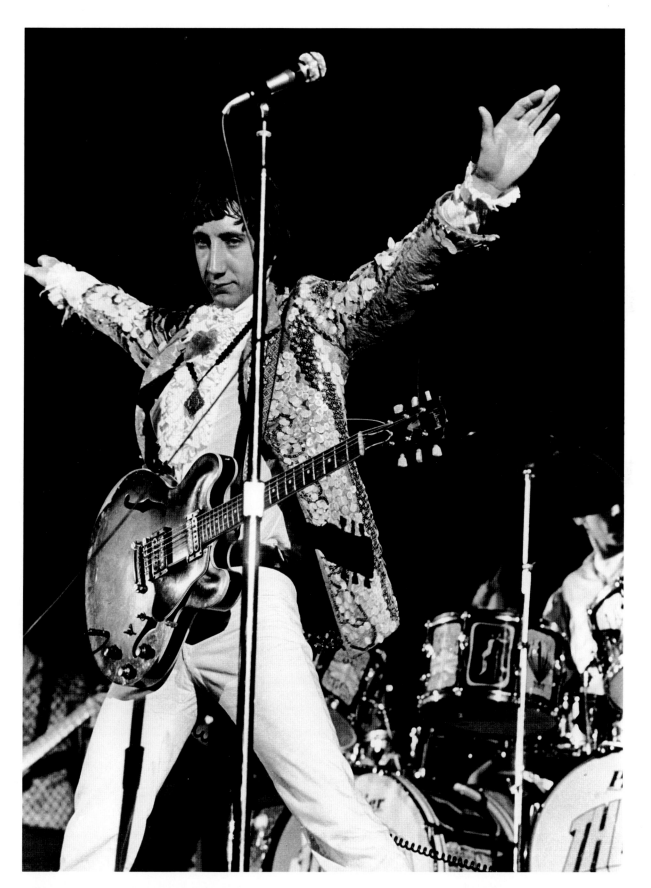

PETER TOWNSHEND

The Who
Cow Palace
San Francisco, Nov 1967

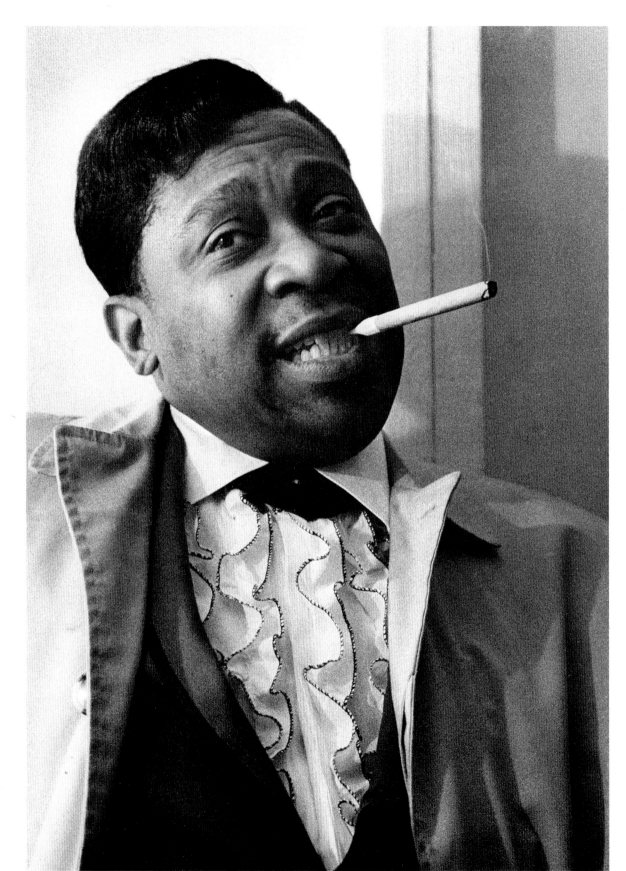

B.B. KING
Backstage
Winterland
San Francisco, Dec 1967

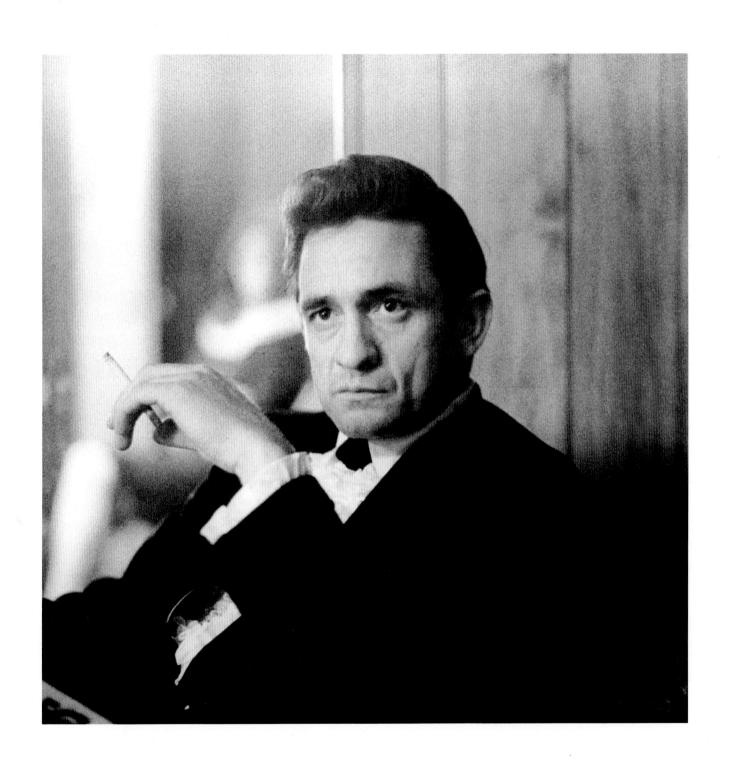

JOHNNY CASH *Backstage at the Circle Star Theatre, Redwood City, Dec 1967*

MUSIC 1968

THIS WAS a year of change, of turbulence and tragedy. Good music was being recorded and released even as the war escalated in Vietnam, even as the Democratic convention imploded in Chicago. In shock, we said good-bye to Bobby Kennedy and Martin Luther King. ● Dylan delivered *John Wesley Harding*, the Beatles gave us *The Beatles* with "Hey Jude," and the Rolling Stones released their twelfth album, *Beggar's Banquet. Rolling Stone* named Jimi Hendrix's *Electric Ladyland* the "Best American and British Rock and Roll Album of the Year." Tiny Tim appeared on "The Ed Sullivan Show." Eric Clapton left Cream. Janis Joplin split from Big Brother & The Holding Company. Sadly, an irrationally uptight group of city officials made it impossible to stage a second Monterey International Pop Festival. ● The Jefferson Airplane turned away from the personal management of Bill Graham to run its own business affairs. The band talked almost seriously about touring with the Doors; on the same show Jim Morrison could belt out "Somebody To Love" while Grace Slick and Marty Balin would croon "Light My Fire." The Beatles closed their Apple Boutique on London's Baker Street by literally giving away everything in the store. Ringo complained that he couldn't find anything to fit him. ● In March, the entire staff of San Francisco's KMPX-FM, "the nation's best rock and roll station," went on strike. The issues were artistic freedom (banned songs and long hair) and money (less than

$2 an hour), in that order. The top pop station in New York City refused to play The Who's new album, *The Who Sell Out*. The station manager, who had earlier punished Jimi Hendrix's music with a similar ban, called The Who record "disgusting," and said he wouldn't "let my children even see the cover." ● In his album and in interviews, Donovan called "upon every youth to stop the use of all Drugs and heed the Quest to seek the Sun, to banish them [all drugs] into the dark and dismal places. For they are crippling our precious growth." Frank Zappa suggested that a jury of peers should be just that. "Young people with long hair cannot be fairly tried by old people with no hair. If you take drugs, the jury should have taken drugs." ● In commenting on his involvement with transcendental meditation, George Harrison allowed, "It's only after acid that it pushes home to you that you're only little, really. There's all that infinity out there and there's something doing it. It's not just us doing it or the Queen doing it, but some great power doing it. I really feel and believe very much in this whole sort of scene, you know, God." ● In *Rolling Stone* Ralph Gleason wrote that "music has the power to change the world" and had already become "so incredibly universal as a means of communication today that a member of the Poor People's March could testify (in Washington) using the words, 'Bob Dylan wrote a song..."Only a Pawn In Their Game,"' and not even one TV commentator felt the need to explain it."

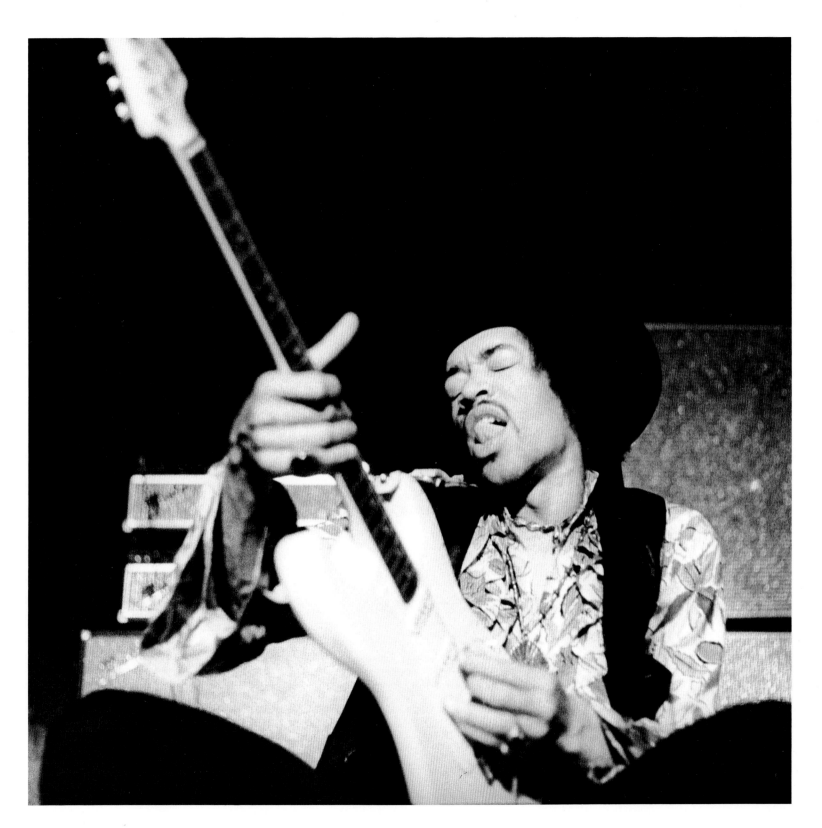

JIMI HENDRIX *Fillmore Auditorium, San Francisco, Feb 1968*

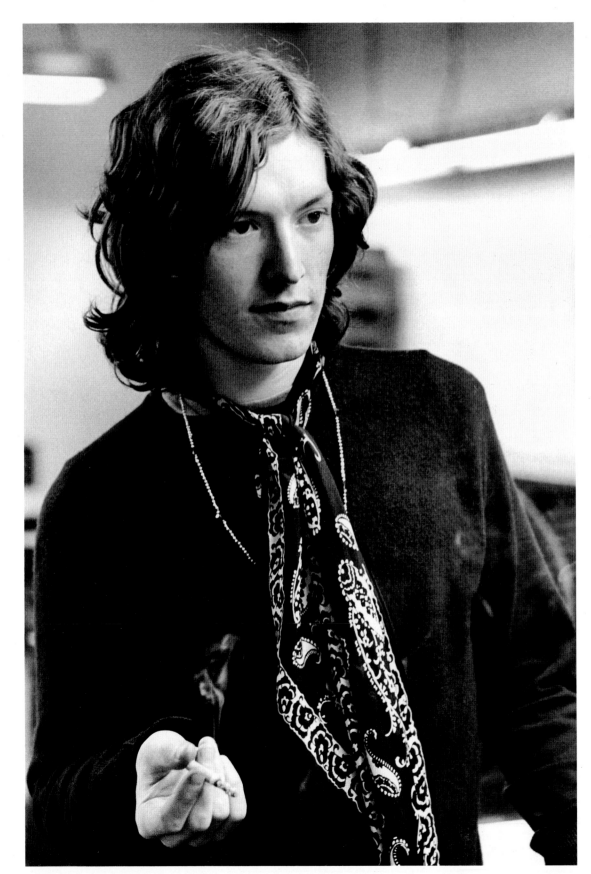

STEVE WINWOOD

At Rolling Stone *offices*
San Francisco, Mar 1968

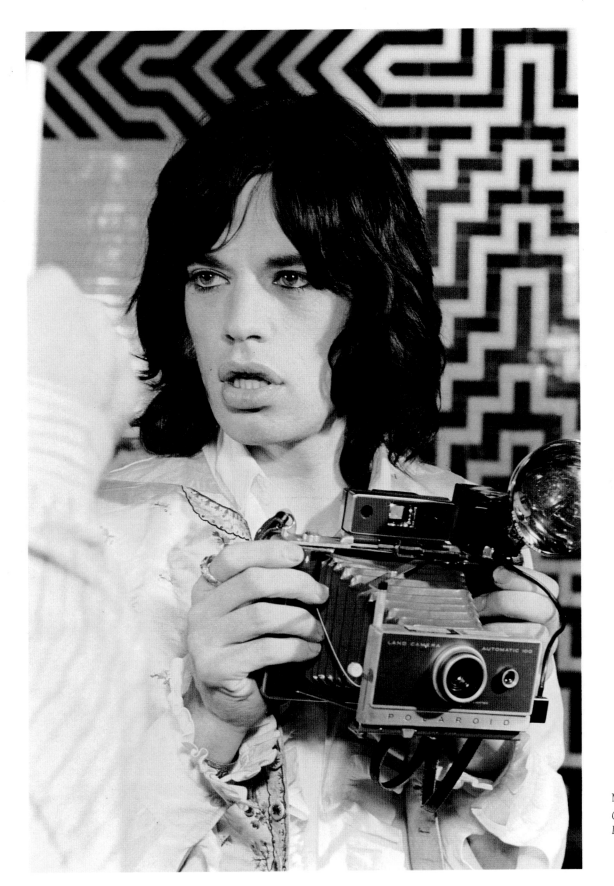

MICK JAGGER
On the set of Performance
London, Sep 1968

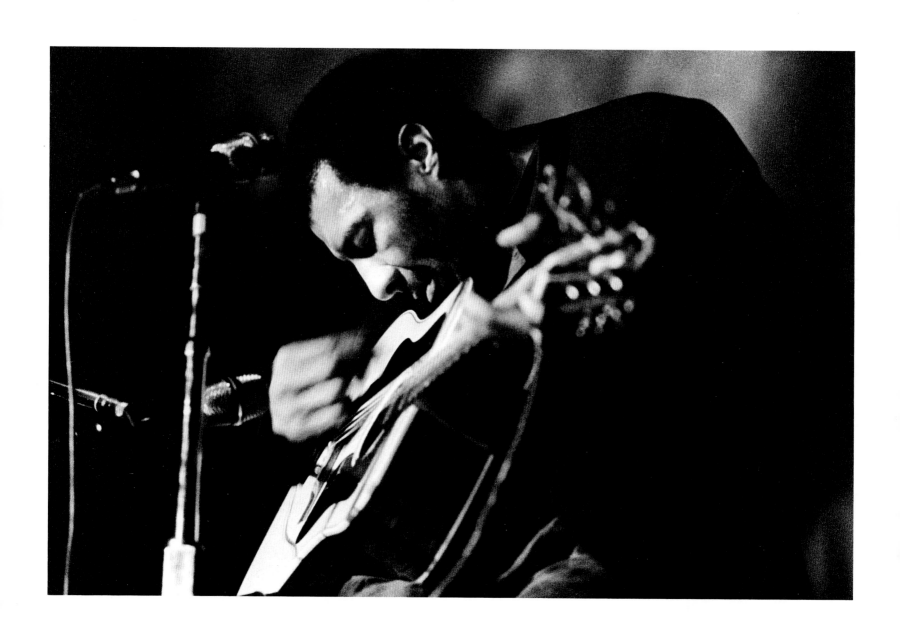

RICHIE HAVENS *Winterland, San Francisco, Jan 1968*

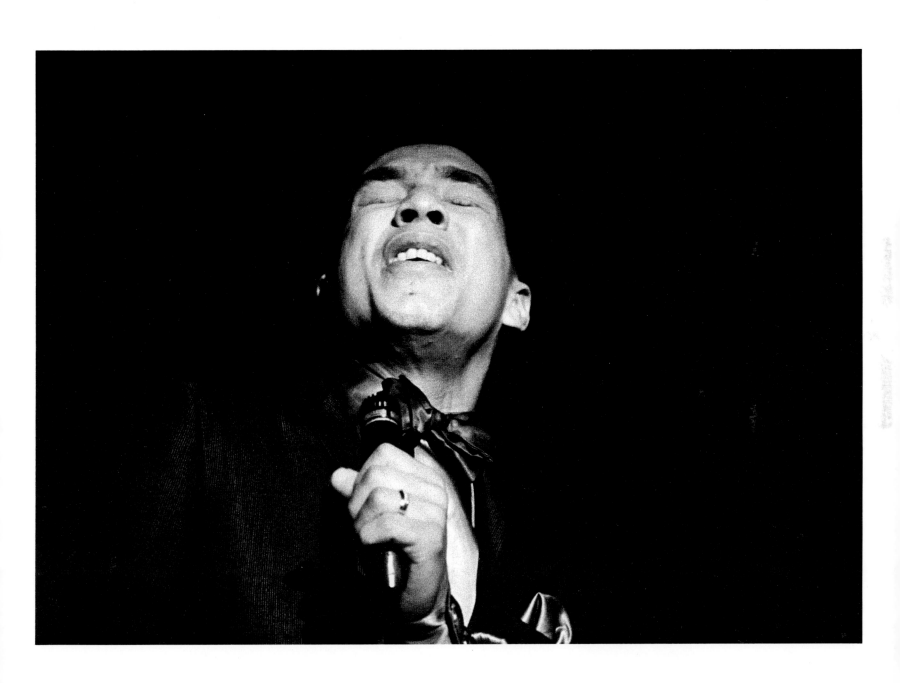

SMOKEY ROBINSON *Bimbo's 365 Club, San Francisco, May 1968*

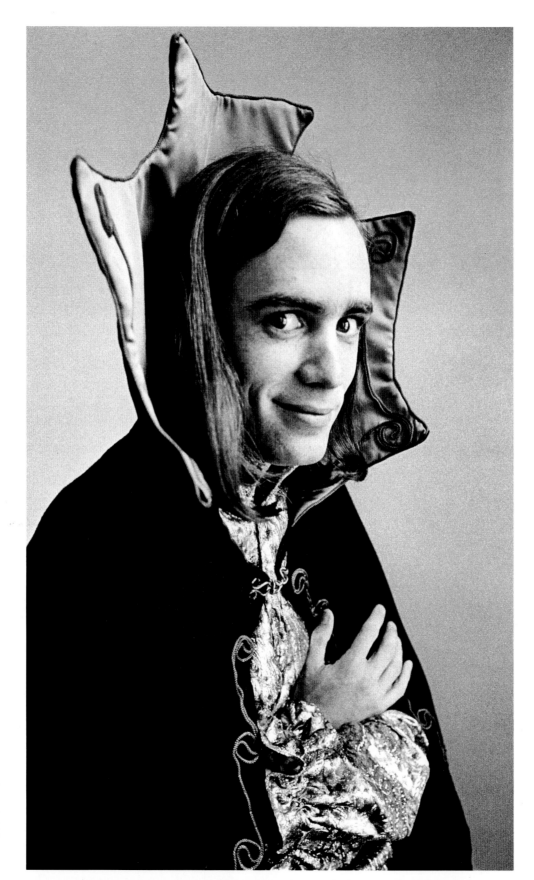

PETER ALBIN
Big Brother & the Holding Co.
in a Jeanne Colon original
San Francisco, Apr 1968

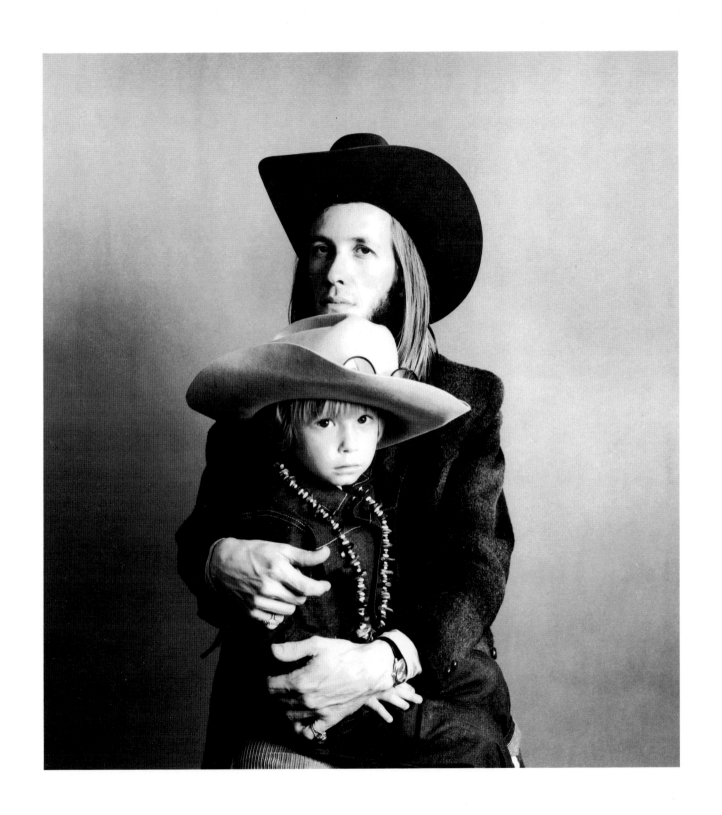

DOUG "SIR DOUGLAS QUINTET" SAHM & SON *Belvedere St. studio, San Francisco, Nov 1968*

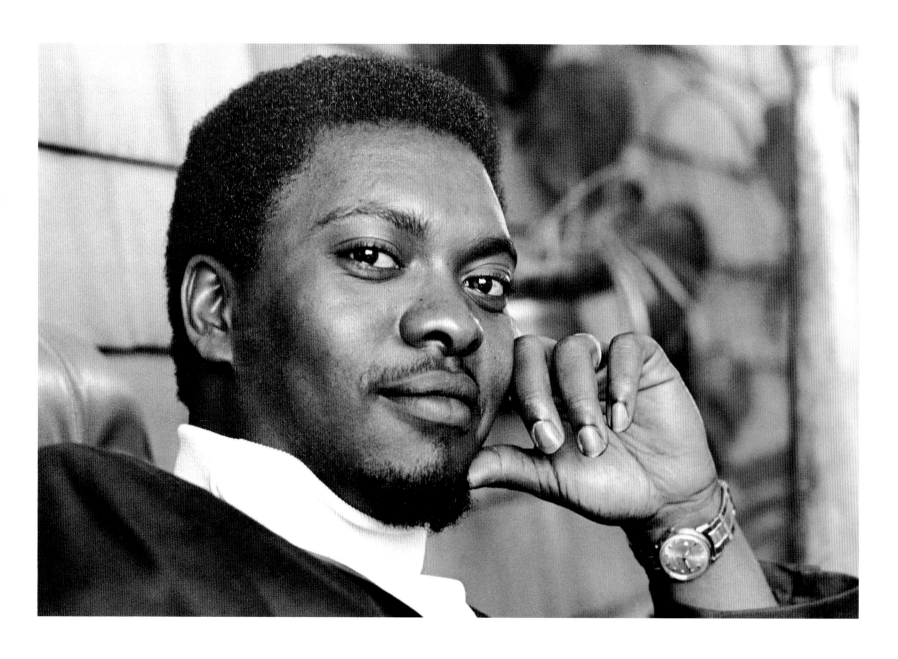

Booker-T Jones *Booker-T & the MG's, Jann Wenner's flat, San Francisco, June 1968*

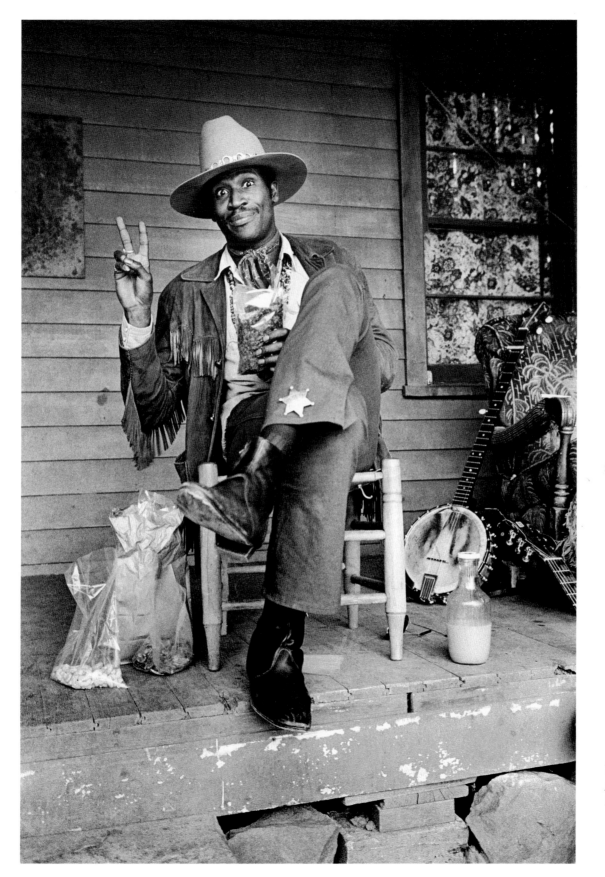

TAJ MAHAL
At home in Topanga Canyon
Los Angeles, Dec 1968

31

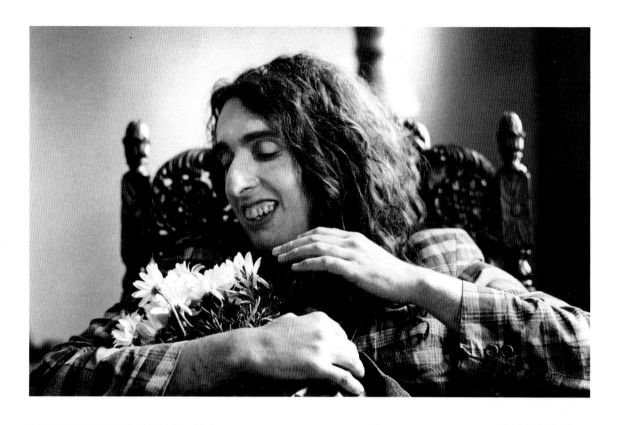

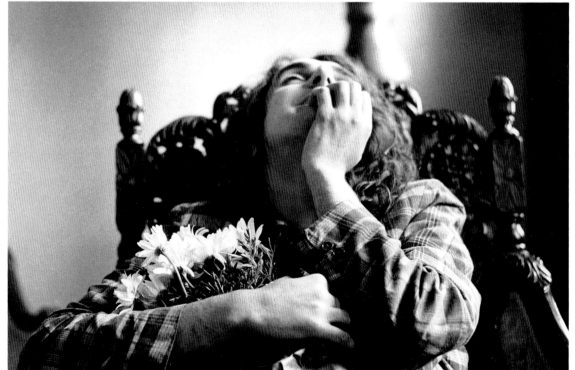

TINY TIM
Interview in Beverly Hills
May 1968

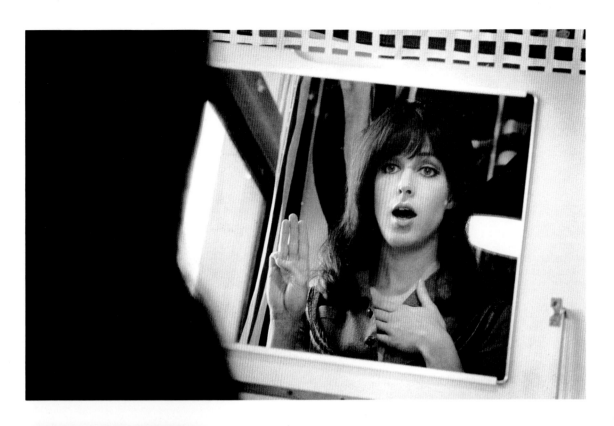

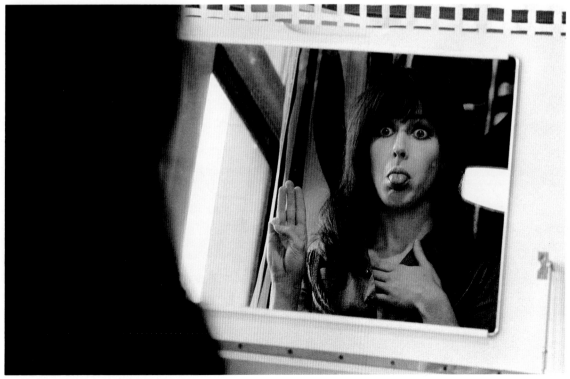

GRACE SLICK
Jefferson Airplane
San Francisco, Jan 1968

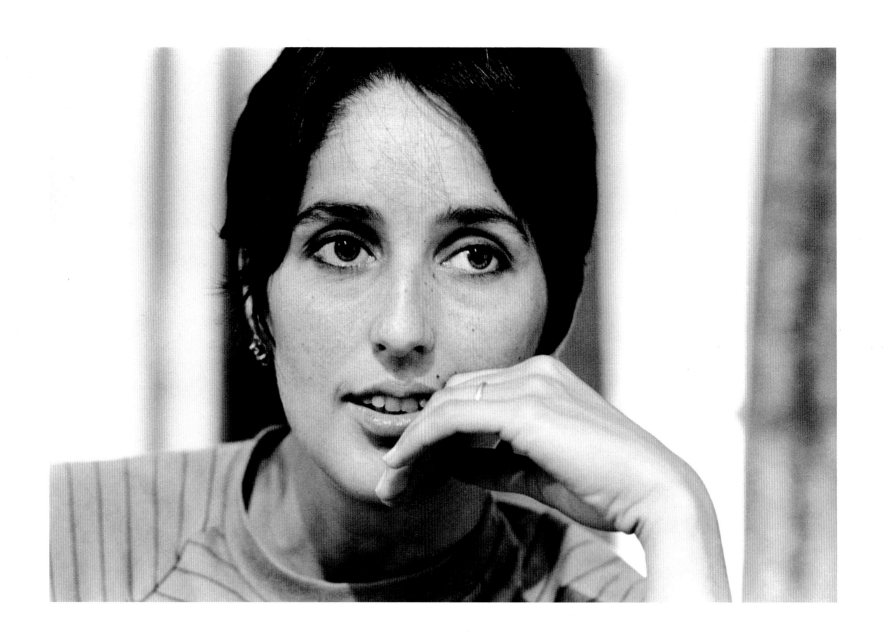

JOAN BAEZ *At the Institute for Study of Non-Violence, Carmel Valley, Oct 1968*

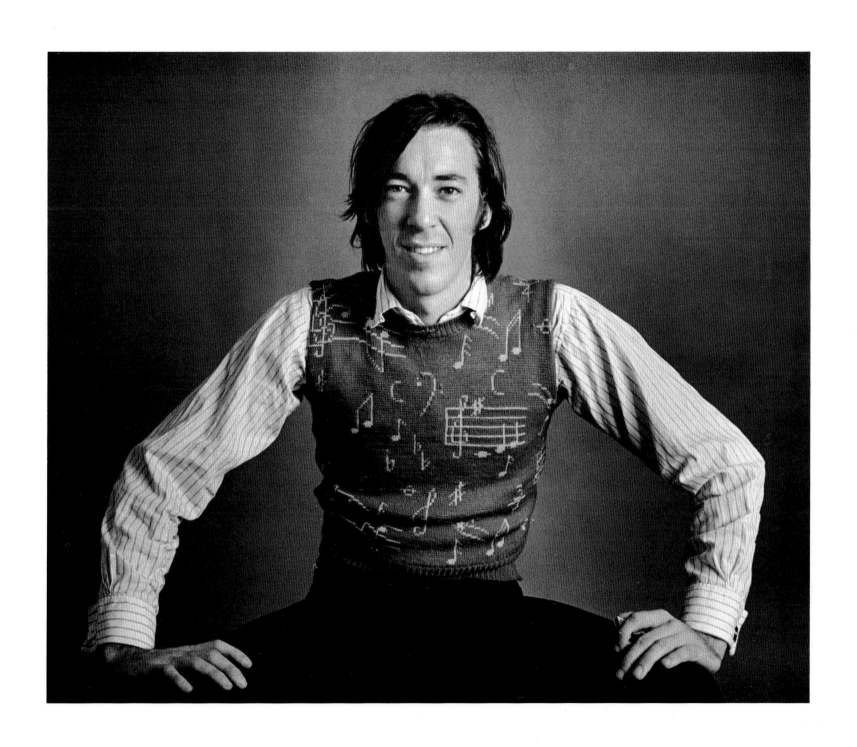

BOZ SCAGGS *Belvedere St. studio, San Francisco, Nov 1968*

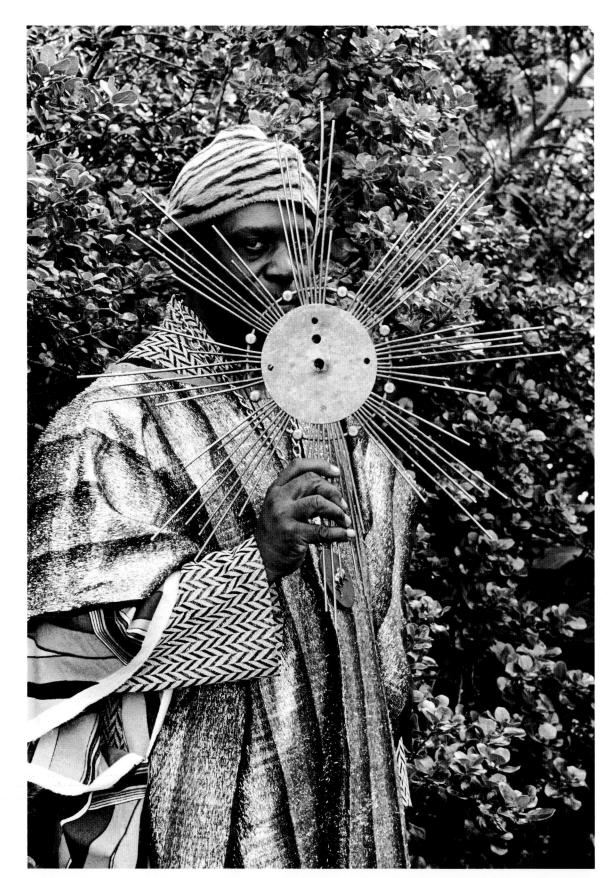

SUN RA
Berkeley, Dec 1968

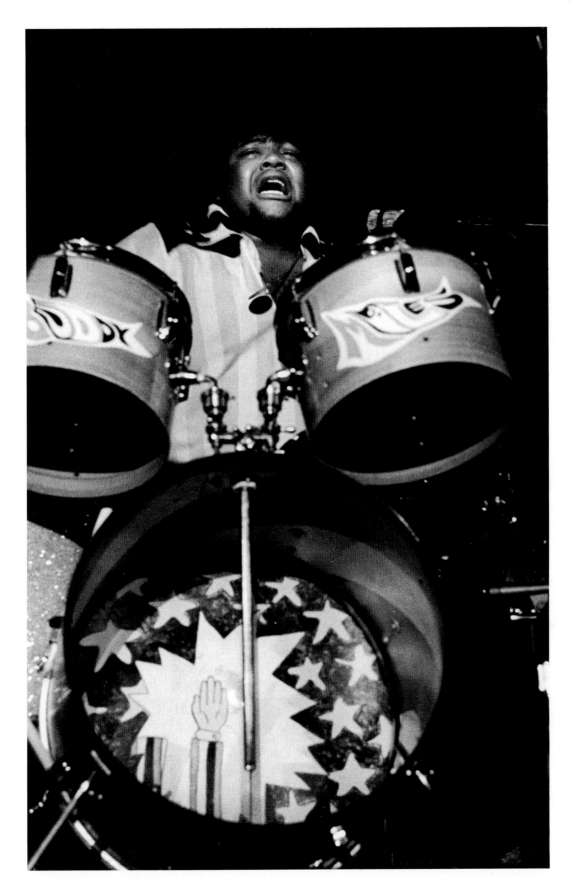

BUDDY MILES
The Electric Flag
Winterland
San Francisco, Jan 1968

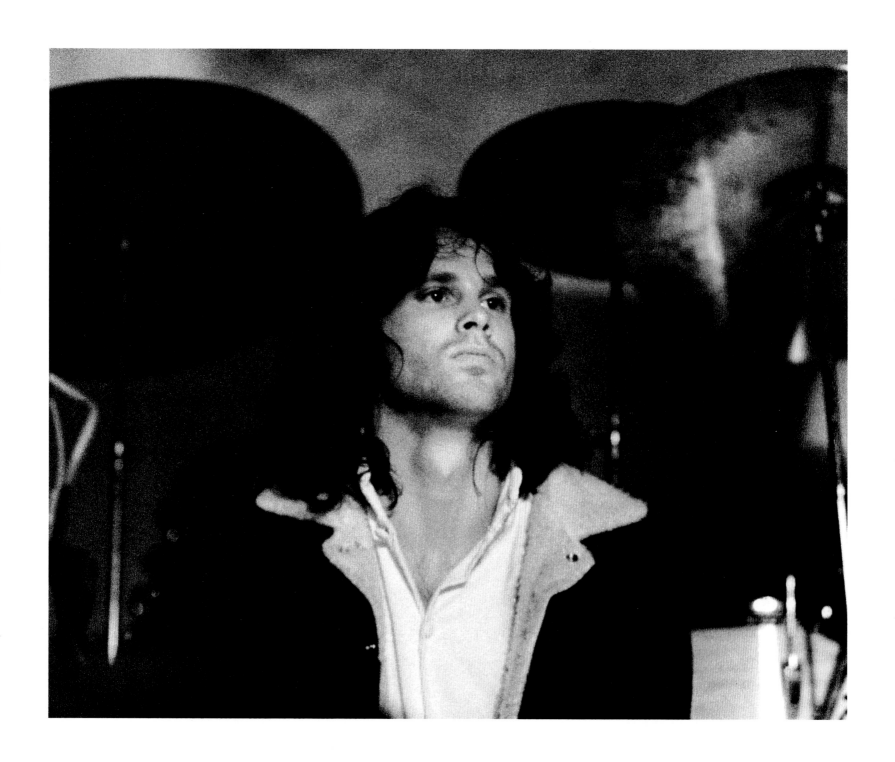

JIM MORRISON *Winterland, San Francisco*

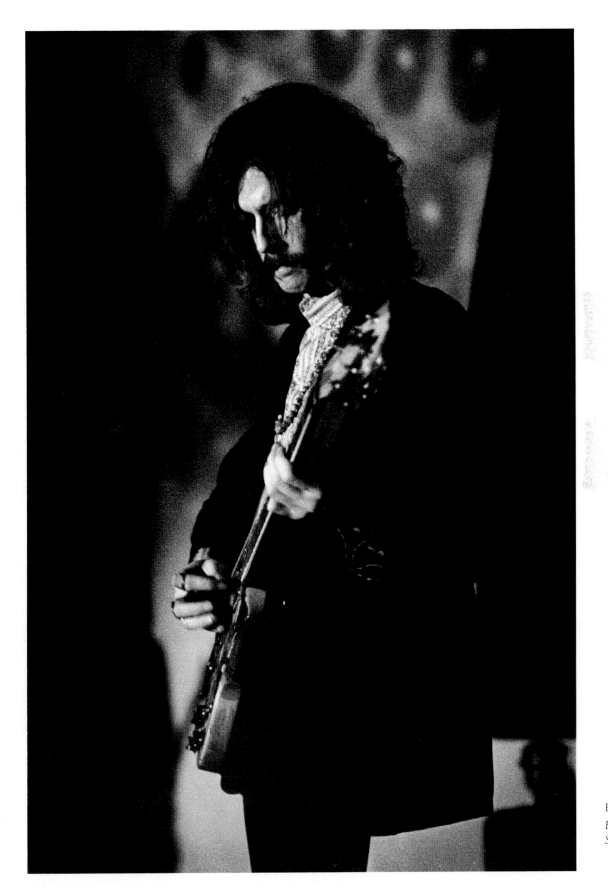

ERIC CLAPTON
Fillmore Auditorium
San Francisco, Mar 1968

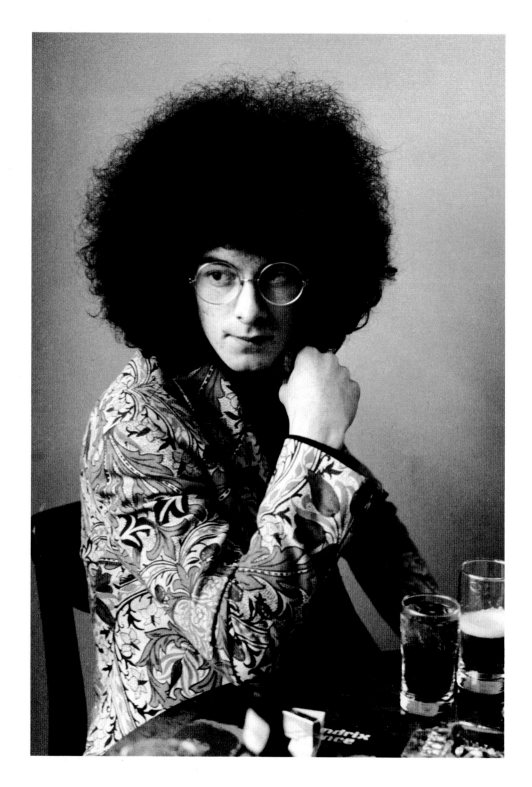

NOEL REDDING *The Jimi Hendrix Experience, Travelodge Motel, San Francisco, Feb 1968*

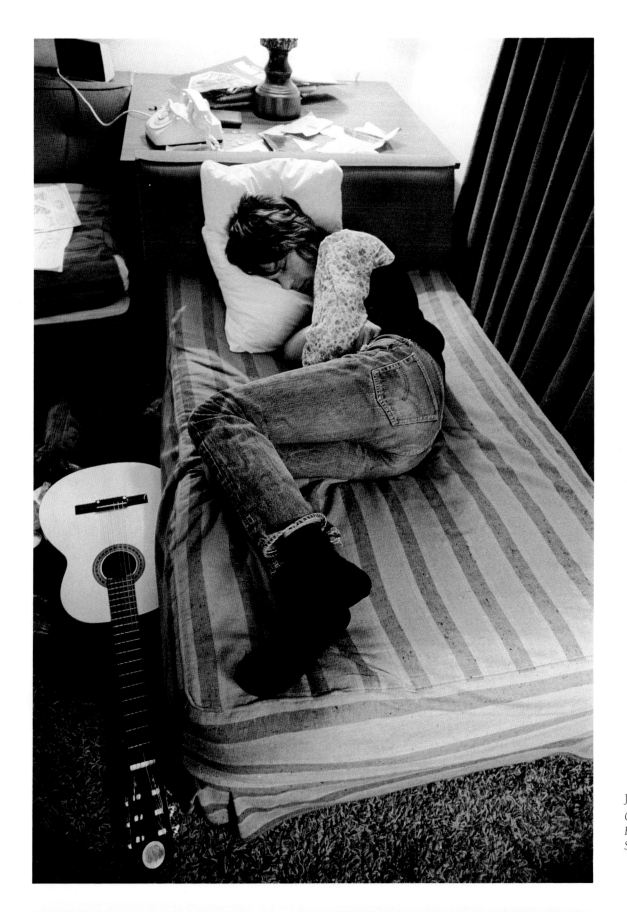

JEFF BECK

On Tour
Holiday Lodge
San Francisco, Dec 1968

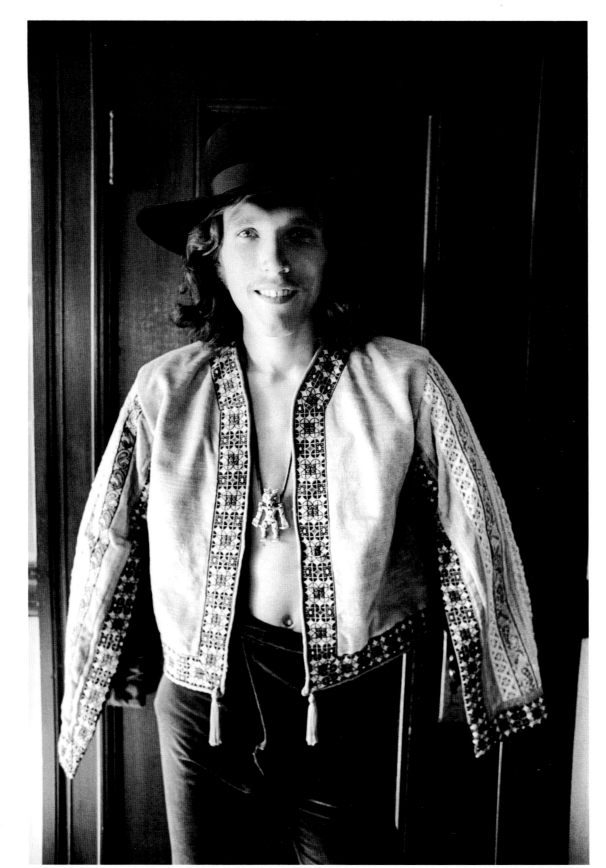

JORMA KAUKONEN
Jefferson Airplane
in a Jeanne Colon original
San Francisco, Apr 1968

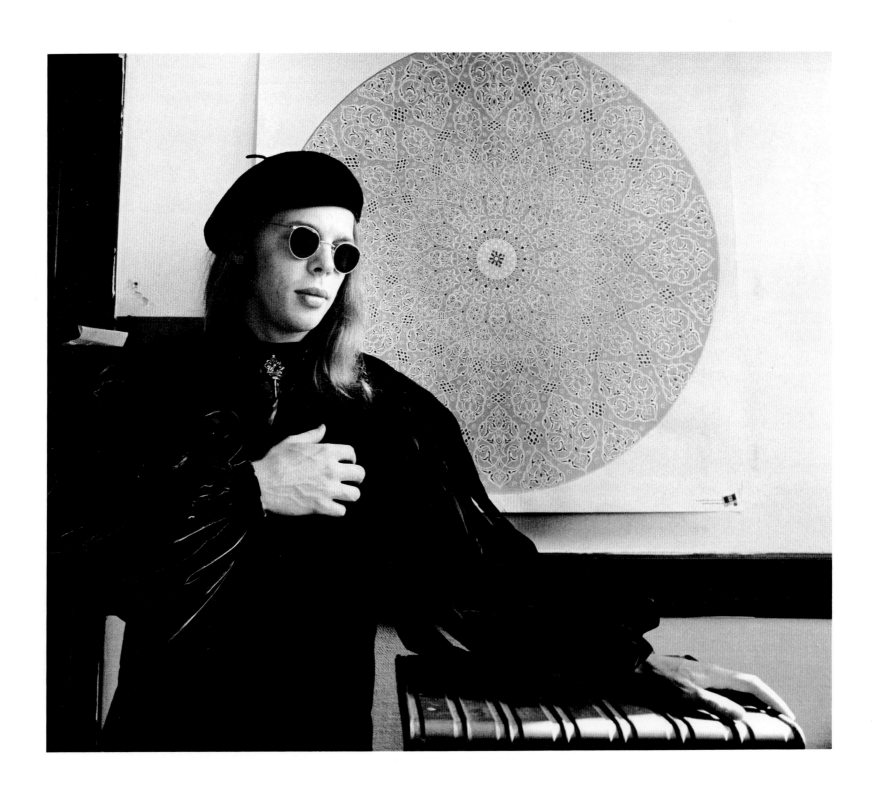

JACK CASADY *Jefferson Airplane, in a Jeanne Colon original, San Francisco, Apr 1968*

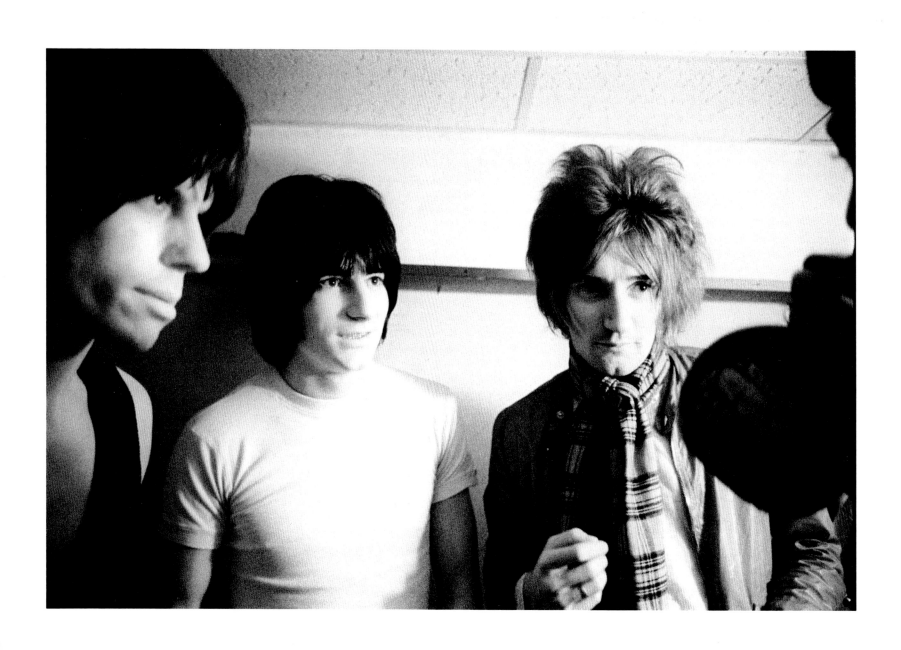

THE JEFF BECK GROUP *Jeff Beck, Ron Wood, and Rod Stewart, Backstage at the Fillmore West, San Francisco, Dec 1968*

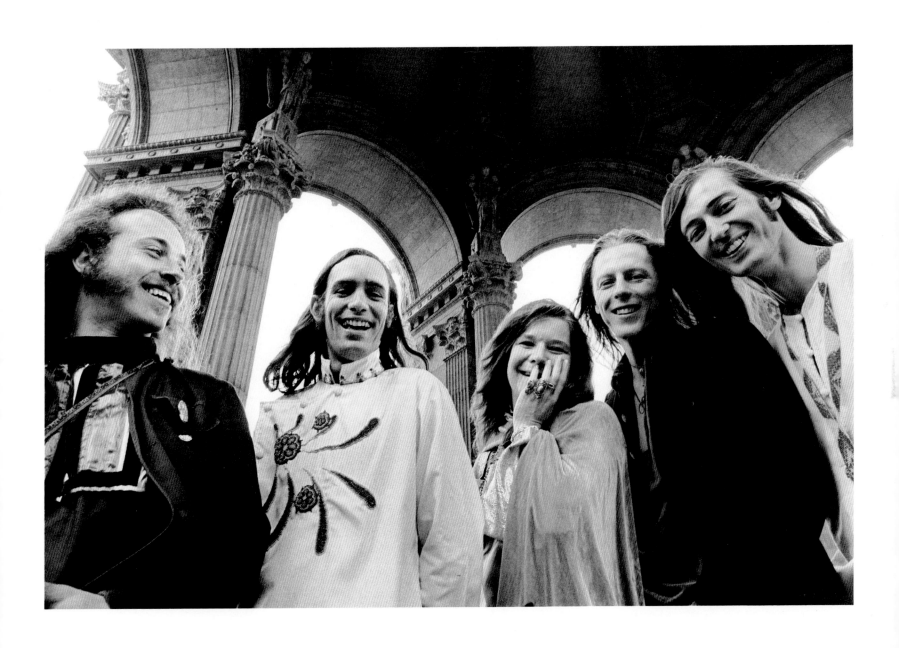

BIG BROTHER & THE HOLDING CO. *Palace of Fine Arts, San Francisco, June 1968*

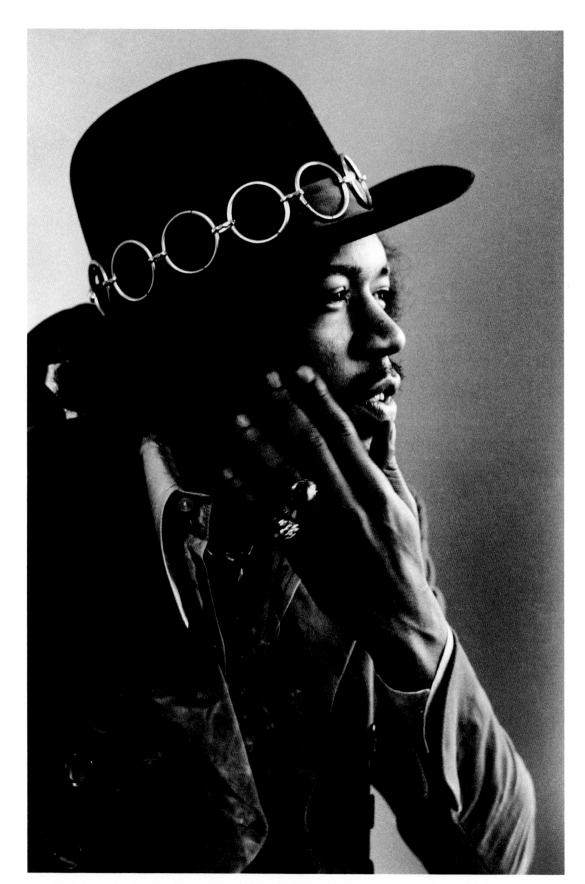

JIMI HENDRIX
Travelodge Motel
San Francisco, Feb 1968

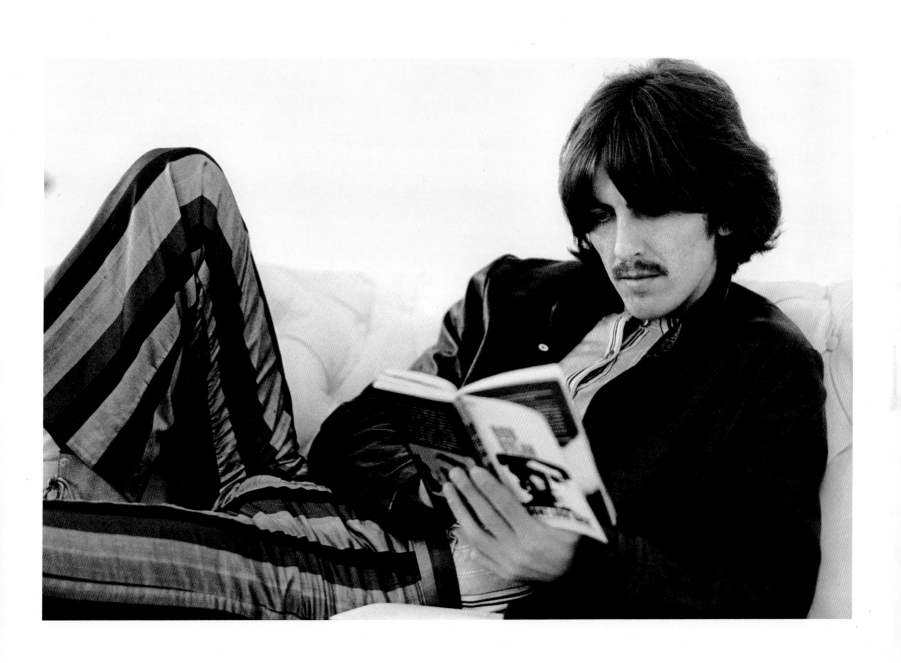

GEORGE HARRISON *Apple Corps Headquarters, London, Sep 1968*

MUSIC 1969

IT WAS not only the year of Woodstock. We were bashed and busted, and walking on the moon, but the music played on to an ever growing audience. ● For the first time since 1966, the Rolling Stones toured the U.S. At the November kick-off concert in Los Angeles, Mick Jagger apologized to the crowd, "Sorry you had to wait so long. We had to wait, too—right?" Bill Graham, who produced the California concerts, said in an interview, "What I hope the Stones do is turn the whole country on, do what the Mets did for New York, wake 'em up. And I think the Stones can do it. Mick Jagger is the greatest fucking performer in the whole fucking world." ● In December the Stones gave their long-promised free concert at the Altamont Raceway near San Francisco. While Jagger sang, the Hell's Angels "security guards" stabbed two young men to death in separate incidents. Mick Taylor, then a new Rolling Stone, lamented later from London, "I've always heard about the incredible violence in America, but I'd never seen it. They're so used to it over there, it's a commonplace thing." ● Also that year, Johnny Cash played a concert inside San Quentin Prison and Janis Joplin performed at London's Albert Hall. Bob Dylan sang at the Isle of Wight Festival of Music, his first scheduled appearance in three years. Elvis Presley was booked into Las Vegas, live for the first time in eight years. Timothy Leary considered a run for governor of California. "My campaign will consist of celebrations," he promised. "We'll travel by caravan, set up teepee headquarters in the central park of each city, gather rock bands together and celebrate." ● Mitch Mitchell and Noel Redding left the Jimi Hendrix Experience, while Neil Young joined Crosby, Stills & Nash. Brian Jones, Dwight Eisenhower, Jack Kerouac and Judy Garland died. Michelangelo Antonioni shot *Zabriskie Point*; and Peter Fonda made *Easy Rider*. The Who released their rock opera, *Tommy*. In Florida, Jim Morrison was slapped with the felony charge of "lewd and lascivious behavior in public by exposing his private parts and by simulating masturbation and oral copulation." Chuck Berry admitted, "The only Maybelline I knew was the name of a cow." ● *Cosmopolitan* guru Helen Gurley Brown took over control of *EYE*, the Hearst Corporation's attempt at a slick youth magazine. In setting a new editorial direction she told the troops, "When girls march (in demonstrations and picket lines), I know they dress up and look pretty to do it ..." ● *Rolling Stone* published a special issue, "American Revolution 1969, The Sound of Marching, Charging Feet." Jann wrote, "The new political movements we feel all around us can no longer be left at the periphery of the artistic consciousness. We must participate ... even if our participation is just by the fact of awareness itself." It was another year of music and madness.

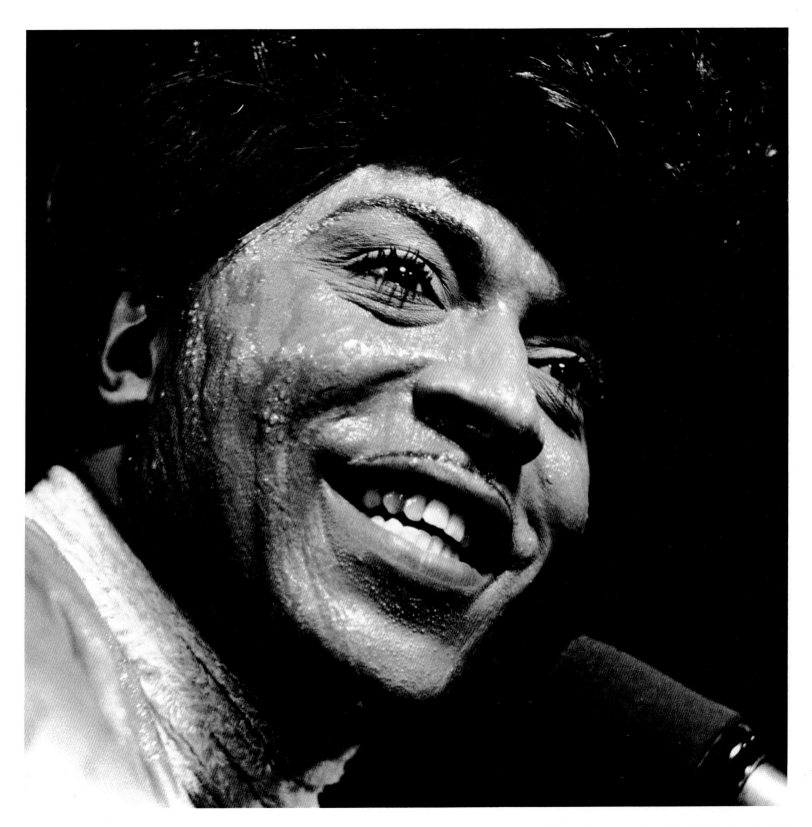

LITTLE RICHARD *Fillmore West, San Francisco, Oct 1969*

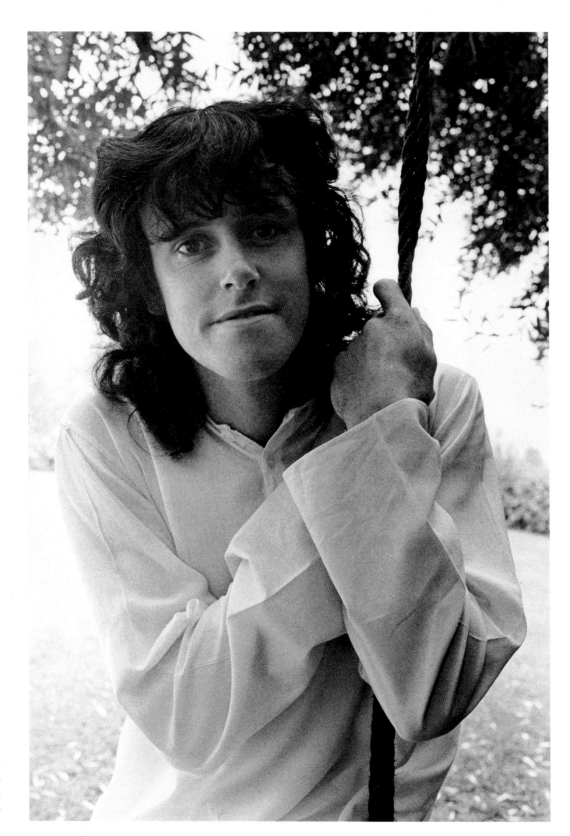

DONOVAN
Portrait for
Vogue Magazine
Los Angeles, Sep 1969

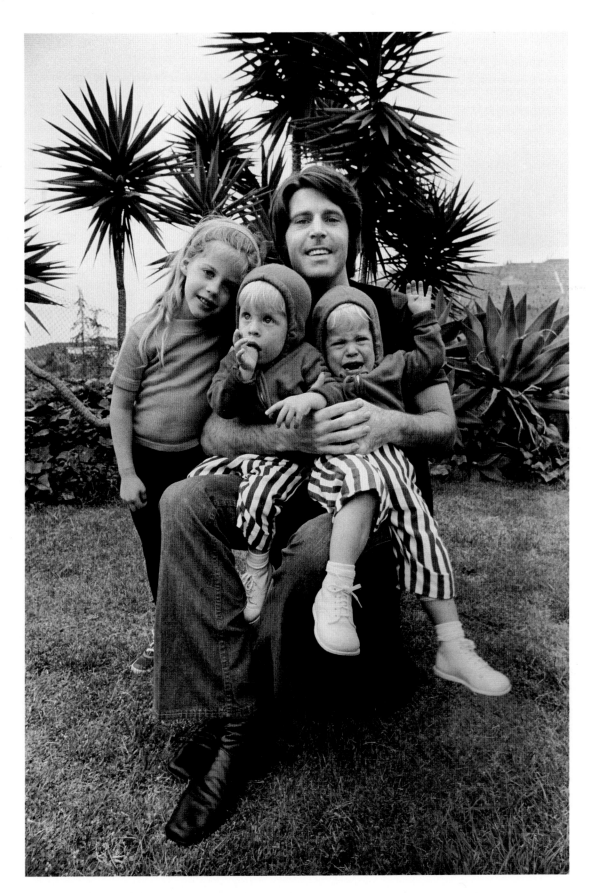

RICK NELSON
At home with daughter
Tracy and twin sons
Matthew and Gunnar
Los Angeles, May 1969

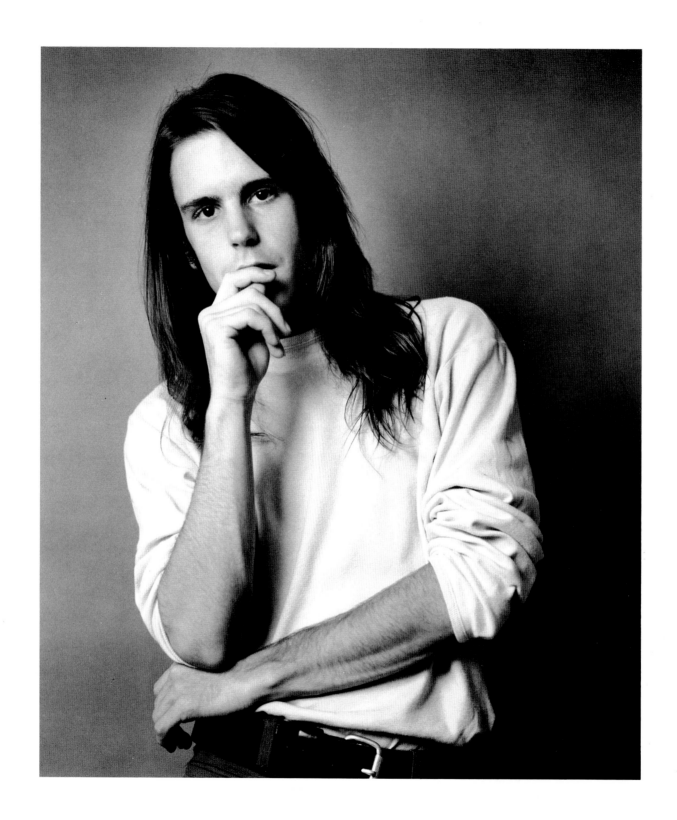

BOB WEIR *The Grateful Dead, Belvedere St. studio, San Francisco, July 1969*

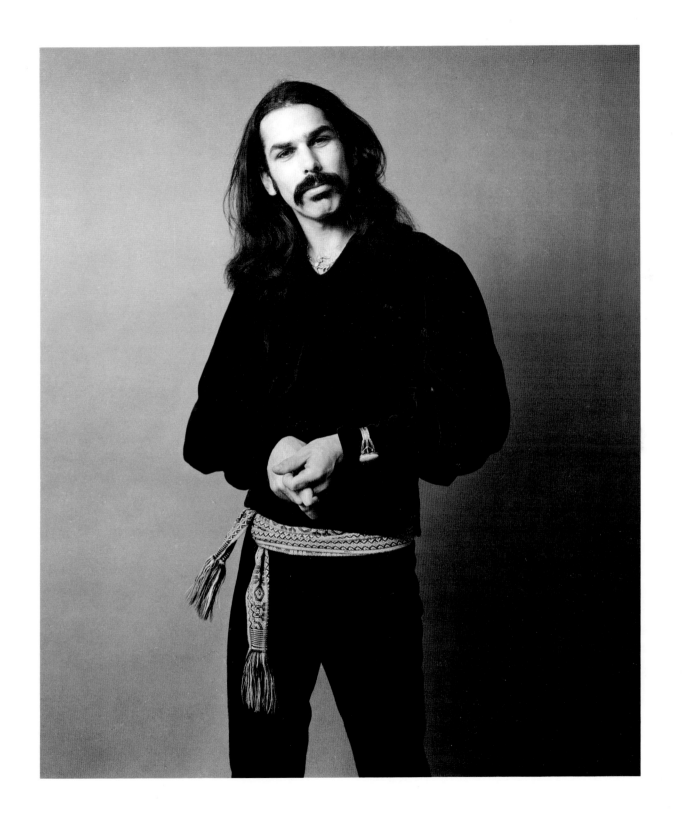

MICKEY HART *The Grateful Dead, Belvedere St. studio, San Francisco, July 1969*

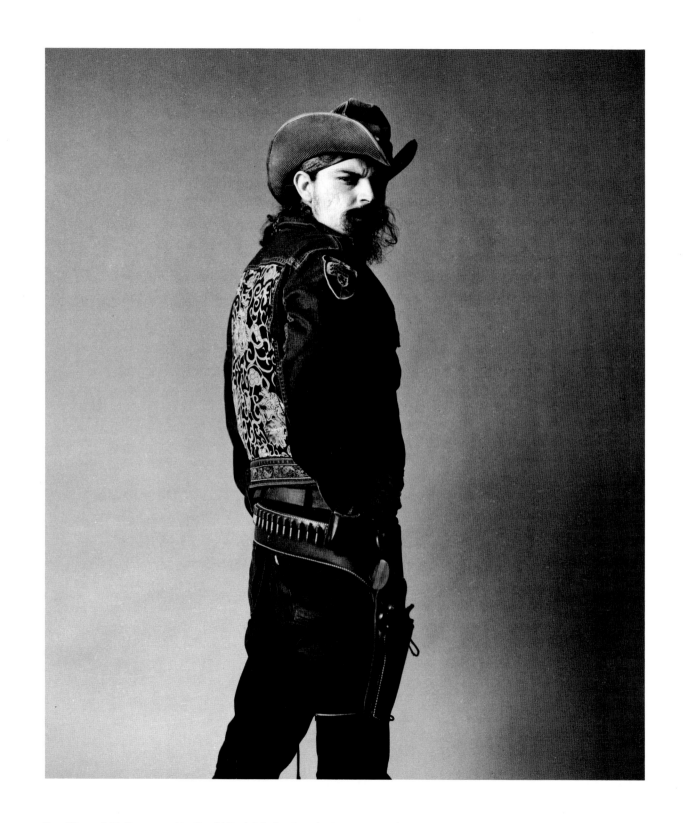

Rod "Pigpen" McKernan *The Grateful Dead, Belvedere St. studio, San Francisco, July 1969*

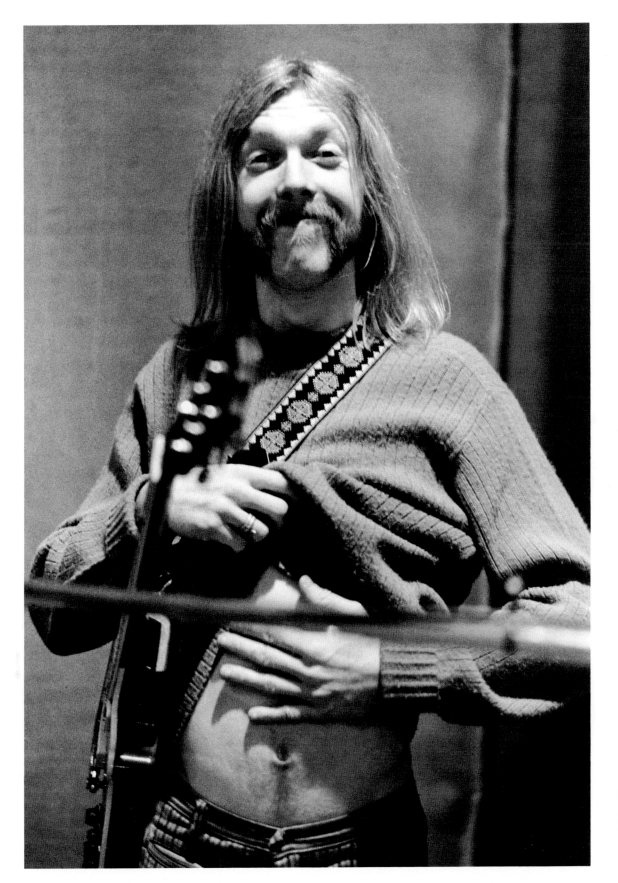

GREGG ALLMAN
Redwal Studios
Macon, Georgia, Mar 1969

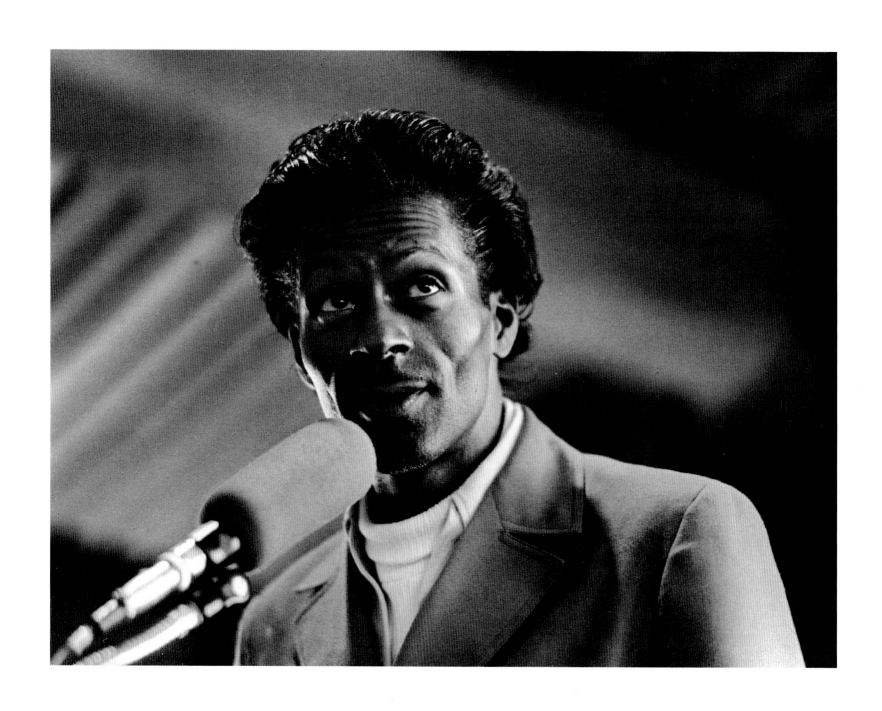

CHUCK BERRY *University of California, Berkeley, May 1969*

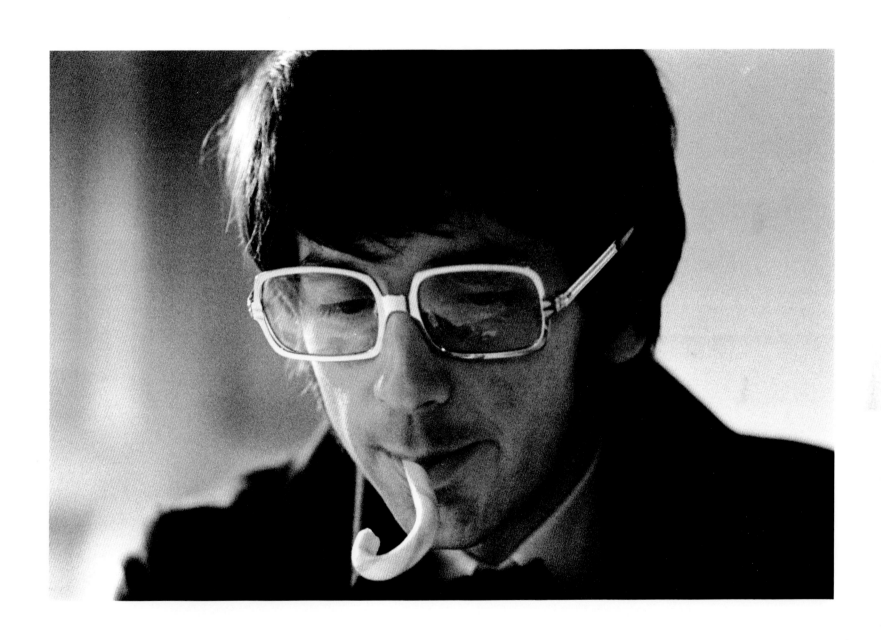

PHIL SPECTOR *At home in Beverly Hills, Jan 1969*

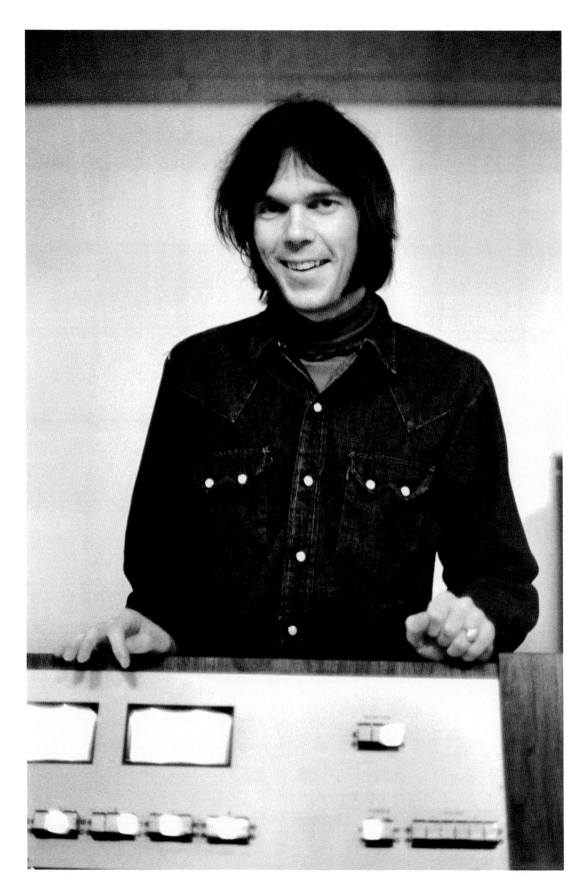

NEIL YOUNG
Los Angeles, June 1969

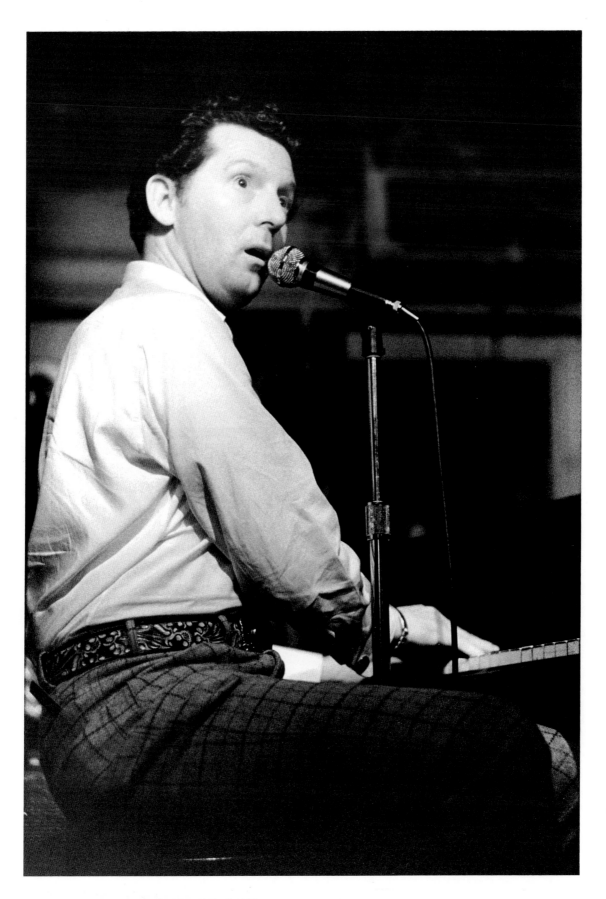

JERRY LEE LEWIS
The Scene
New York City, Mar 1969

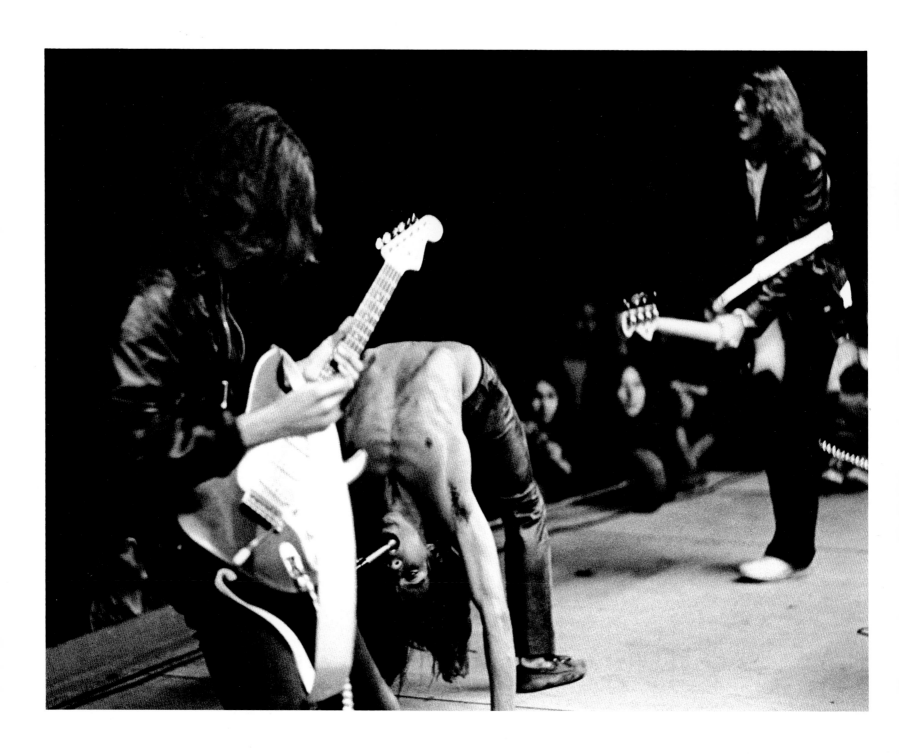

IGGY STOOGE *Later Iggy Pop, Mt. Clemens Pop Festival, Michigan, Aug 1969*

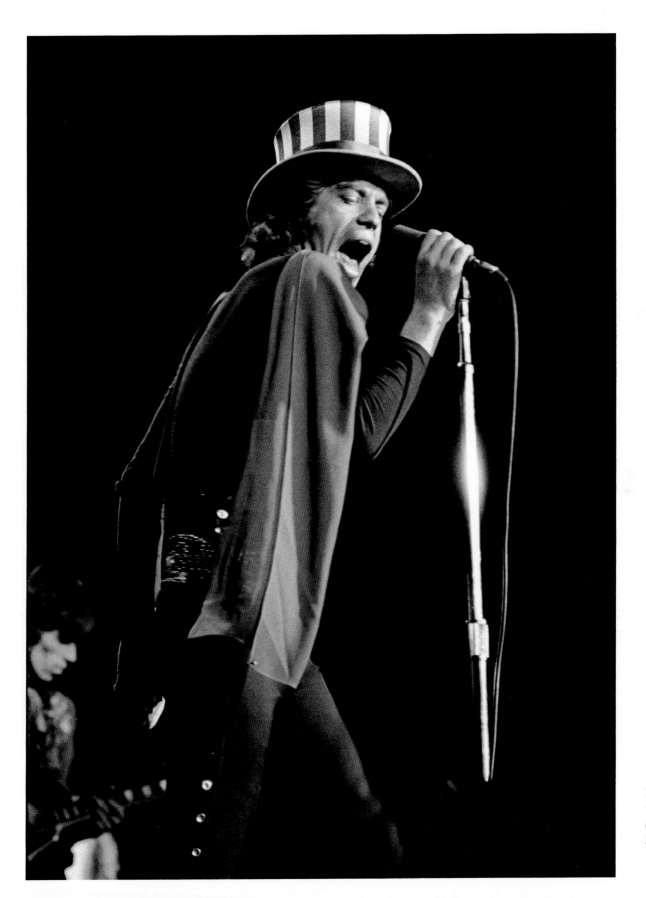

MICK JAGGER
The Rolling Stones
Oakland Coliseum Arena
Nov 1969

MUSIC BEYOND THE 60s

NINETEEN SEVENTY was not a hopeful beginning to the new decade. Dead before the end of the year were Jimi Hendrix, Janis Joplin, and four students shot down at Kent State. Jim Morrison still had one year to live. ● Harmony and chaos shared a lyrical consciousness. From Van Morrison came his visionary, imaginative classic, *Moondance*. From Charles Manson — available by mail only, since no record company would distribute it — his 14-song album, *Lies*. ● John Lennon wore a "hur" coat, a shaggy black garment made from the hair of 30 Asian women. Janis Joplin dedicated her Madison Square Garden concert to Joe Namath. Jimi Hendrix's Band of Gypsies simply disappeared. The resurrection of Elvis continued; the Pelvis, backed by the Sweet Inspirations, knocked them dead, live in Las Vegas. ● The retail price of the Beatles' *Abbey Road* album drew loud complaints from fans. Capitol Records blamed the increase to $6.98 on bigger royalties due the Beatles. The price of *Rolling Stone* went from 35 to 50 cents in March 1970. At a high (for the times) $4 a ticket, *Woodstock*, the film, went into national release. The 16mm multi-screen three-hour epic was a powerful and honest second-generation visit to the mother of all festivals. ● Ken Kesey, the original Merry Prankster, promised, "I'm going to stop using profanity and start cursing. Profanity is just a waste of space, but a good curse is hard to do."

From Little Richard: "I don't think God intended us to have hatred against any man, because hatred is a sickness, and God wanted us to be well, we should stay well." ● Even in 1970 it was clear that the environment was at risk. Music mattered, politics mattered. But humanity was steadily and irrevocably fouling its nest and eventually that could matter even more. Which is why we urged Jann to publish *Earth Times*. Ahead of its time, perhaps, and still searching for editorial cohesion when it vanished, *Earth Times* posed fundamental questions about the future of our planet that have yet to be fully answered. ● In a June 1970 issue of *Rolling Stone*, an Elektra Records ad stated boldy, "When music becomes the mirror of the chaos and frustration in our troubled world, then it becomes our responsibility, ultimately our duty, not just to listen, but to act." ● Speaking to a writer more than twenty years later, Bob Dylan glanced back. "There used to be a time when the idea of heroes was important. People grew up sharing those myths and legends and ideals. Now they grow up sharing McDonald's and Disneyland. A lot of people say the 60s generation didn't turn out well, that they didn't live up to their dream or follow through. And they may be right. Yet people today are still living off the table scraps of the 60s; they are still being passed around — the music, the ideas. There was still a lot that no one else has been able to do."

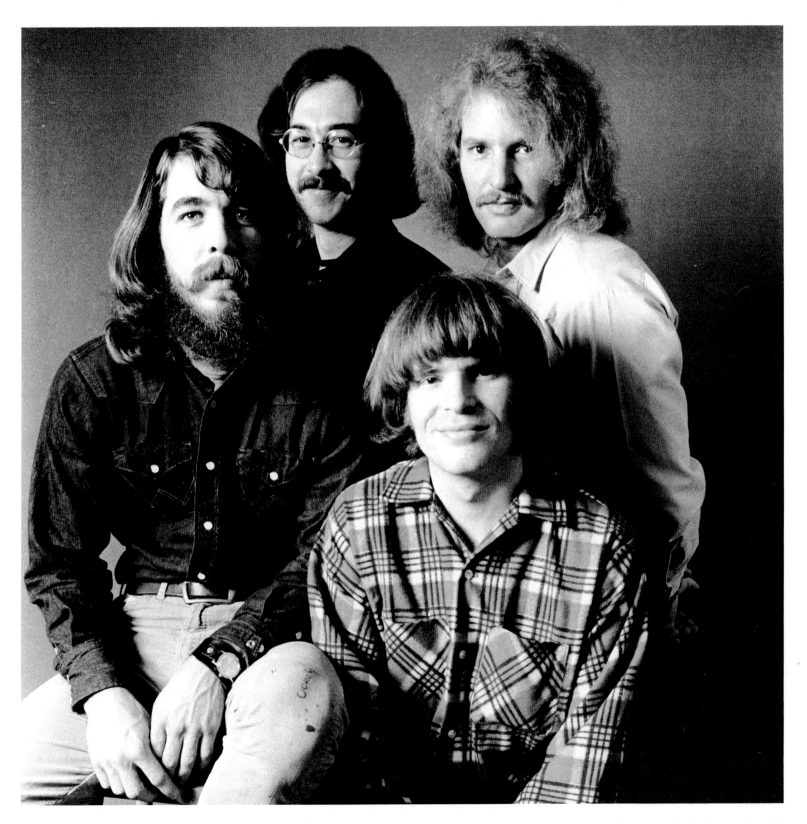

CREEDENCE CLEARWATER REVIVAL *Belvedere St. studio, San Francisco, Jan 1970*

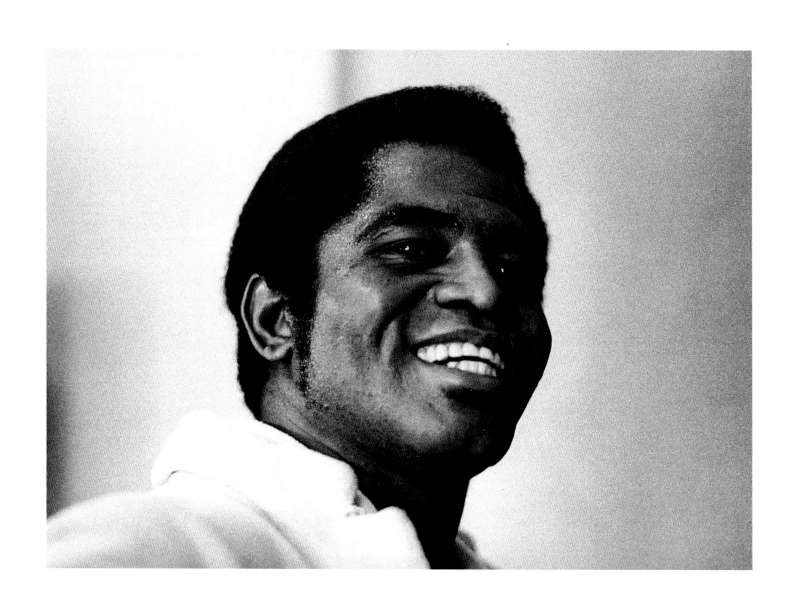

JAMES BROWN *Backstage, Civic Auditorium, San Francisco, Jan 1970*

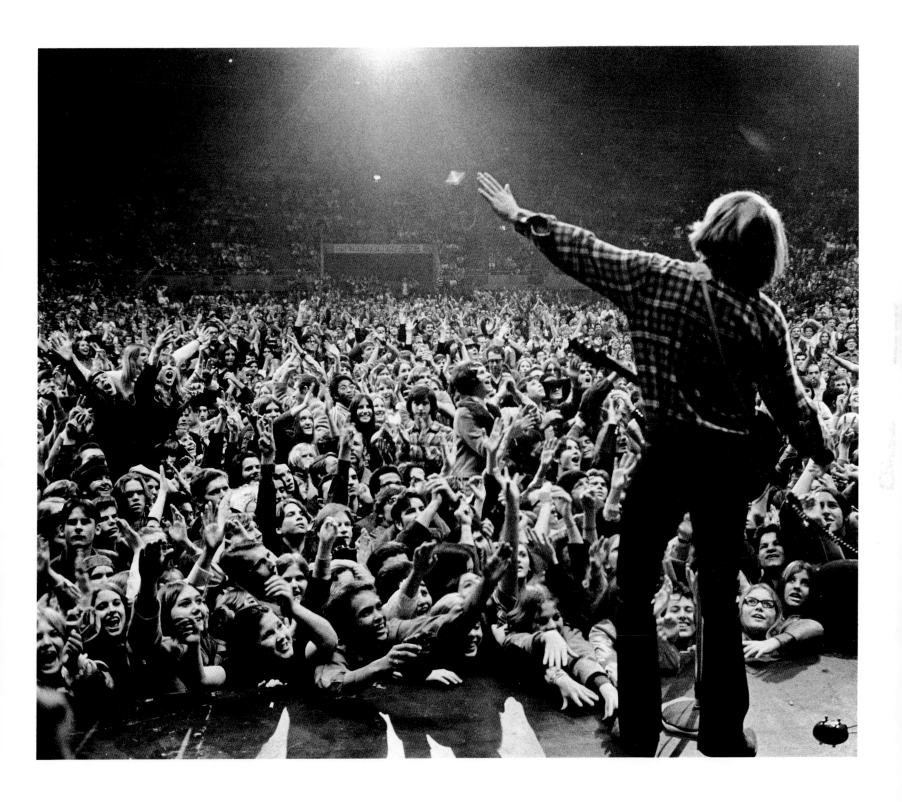

JOHN FOGERTY *Creedence Clearwater Revival, Oakland Coliseum Arena, Jan 1970*

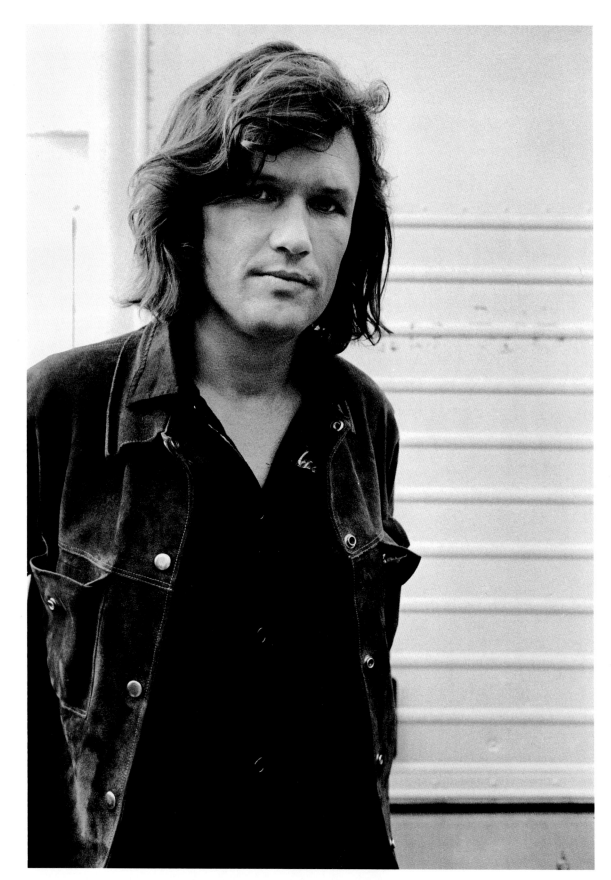

KRIS KRISTOFFERSON
On the set of The Dealer
Los Angeles, Dec 1970

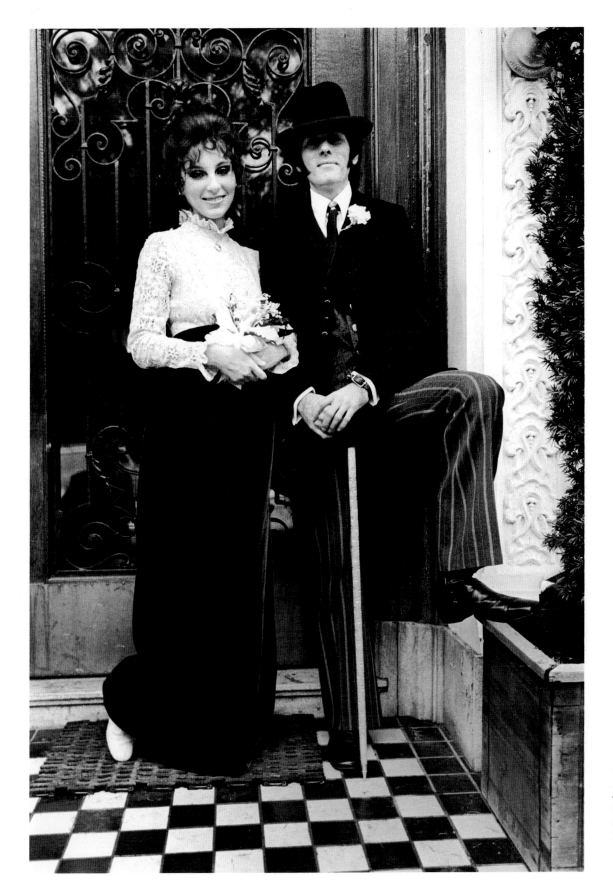

WEDDING PORTRAIT
Jefferson Airplane's
Spencer Dryden
and Sally Mann
San Francisco, Jan 1970

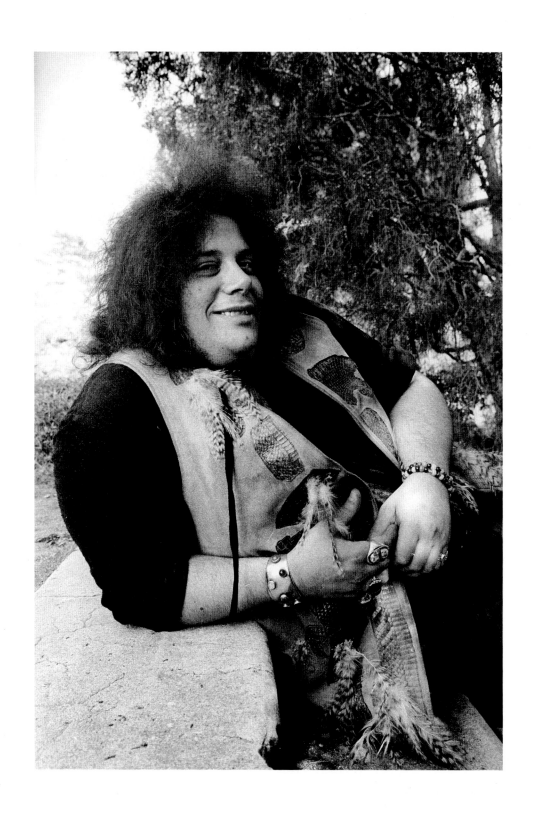

LESLIE WEST *Denver, May 1970*

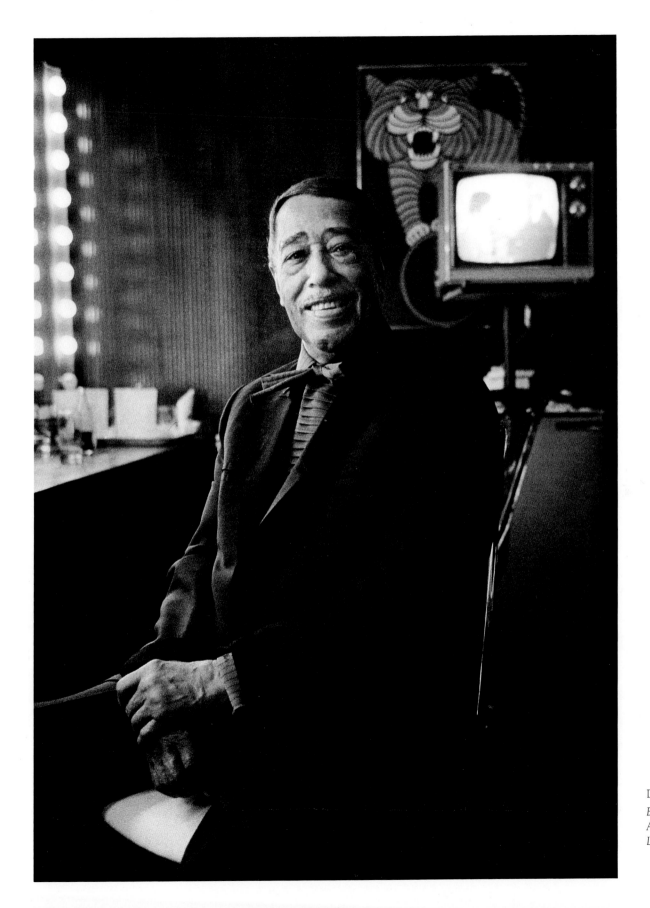

DUKE ELLINGTON

Backstage
Ambassador Hotel
Los Angeles, Mar 1972

THE GROUPIES

THE GROUPIES had style. They were approachable, generous, communicative and appealingly eccentric. They were also enormously photogenic and the most willing of subjects. For musicians, being photographed was just part of the job, tolerated but seldom enjoyed. For the groupies, posing for the same camera was a mark of honor, a tangible confirmation of their place in the scene. ● "When we tell you what a groupie is, will you really understand?" That headline in a *New York Times* full-page ad boldly announced an issue featuring the "Girls of Rock," and suggested that *Rolling Stone* was about to reveal a major secret. But there was no secret and there was really very little to understand. That some women are drawn to power, money and fame was nothing new. Most groupies loved the stars more for their stardom and its trappings than for the music. It was that simple. ● What did happen in the pages of *Rolling Stone* was that the groupies posed and talked, revealed themselves, opened a window to their world. That February 1969 issue was fascinating, its raw honesty compelling if slightly disturbing. Not surprisingly, the groupies described a world where sex without love was the common denominator. ● And it was a competitive world. Since being noticed was prerequisite to being chosen, packaging was everything to a groupie. Her success depended on her look, and her look was limited only by her imagination. ● Groupies, like photographers, traffic in illusion; photo sessions with them were filled with constant surprises. They arrived at the studio lugging suitcases filled with clothes and accessories and make-up. They would combine feather boas with tie-dye skirts, accent antique Victorian dresses with native American jewelry, or climb into some wonderfully indescribable homemade outfit. It was dress-up time for the camera, an ever changing visual treat, a photographer's delight. ● Frank Zappa believed in the groupies' considerable creative impulses. He compared the works of the Plaster Casters of Chicago to neon sculpture, and supported the musical aspirations of his would-be performance artists, the GTOs (Girls Together Occasionally/Often/Only). But he noted wistfully that it is "very rare that chicks hit on me. I think they're afraid of me." ● Groupie skills at packaging didn't escape the musicians themselves. Alice Cooper borrowed Miss Mercy's mega-dose of eye shadow. David Bowie probably took inspiration from them all. Two decades later costumes continue to cross gender lines, especially as music videos compete for attention —much like the groupies themselves. ● For the musicians, of course, groupies were a delightful fringe benefit. Country Joe McDonald happily declared that "groupies are beautiful. They come to hear you play, they throw flowers and underpants, they give you kisses and love, they come to bed with you. They're beautiful. We love groupies."

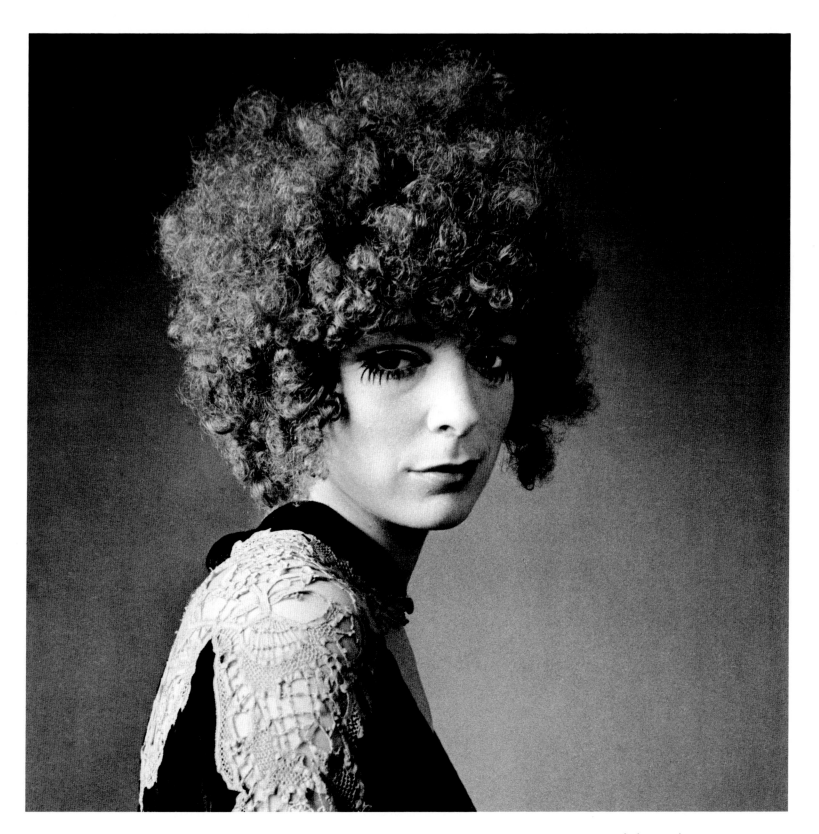

KAREN SELTENRICH *Belvedere St. studio, San Francisco, Nov 1968*

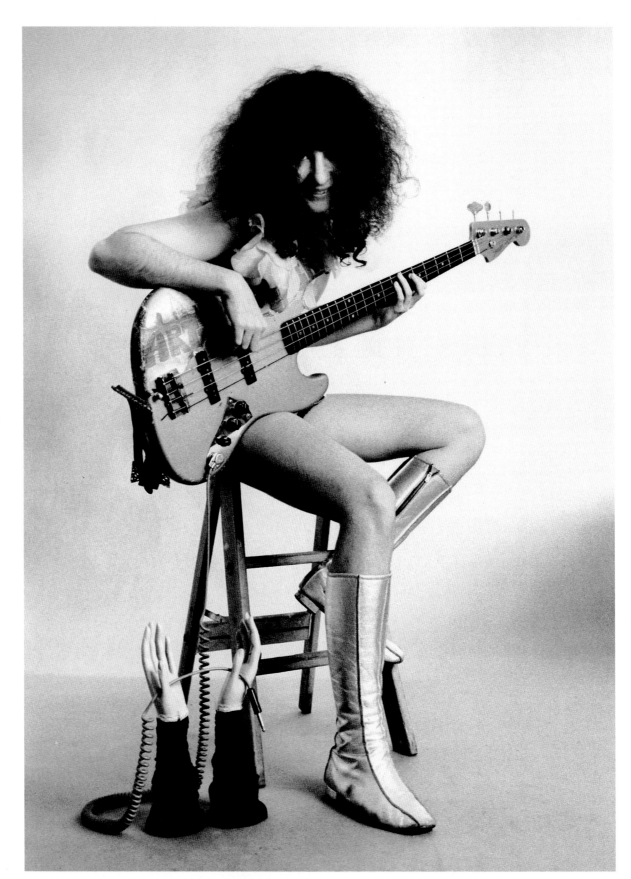

TRIXIE MERKIN
Belvedere St. studio
San Francisco, Nov 1968

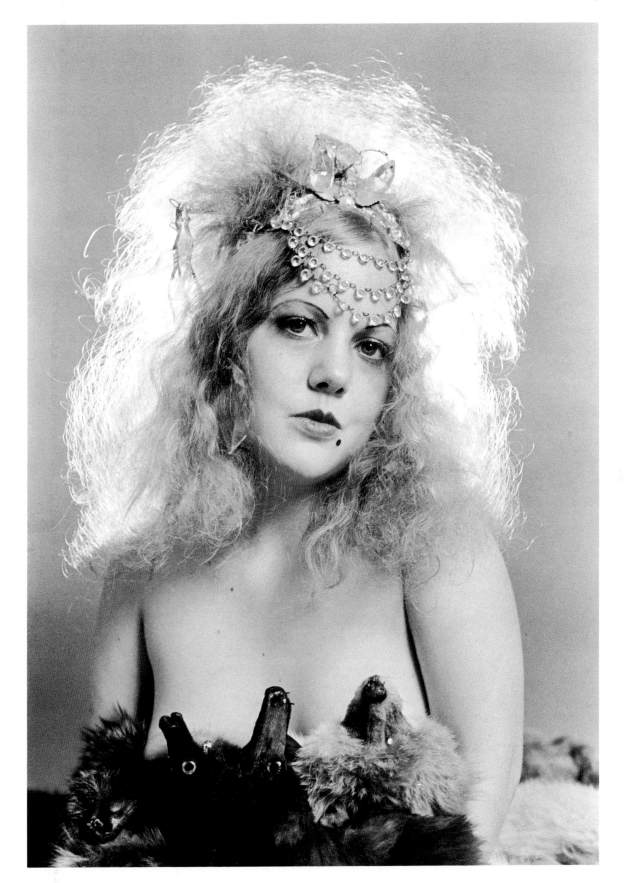

HARLOW
Belvedere St. studio
San Francisco, Nov 1969

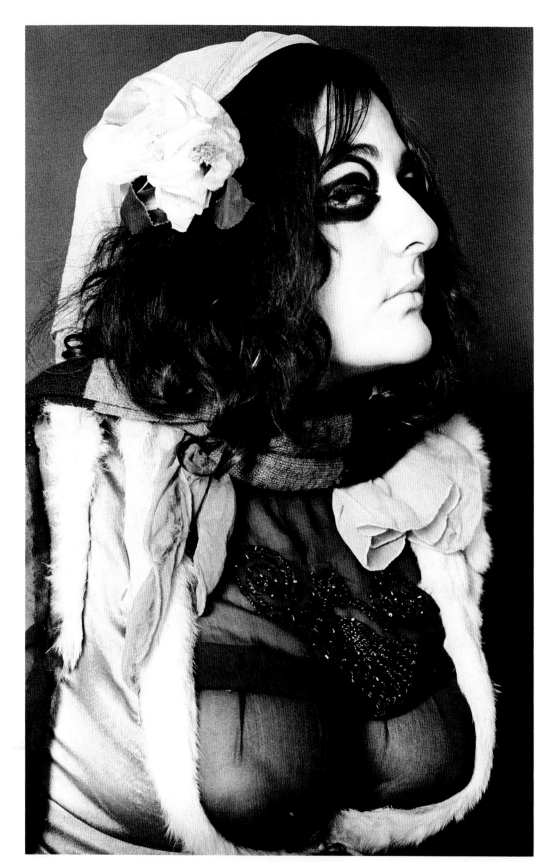

MISS MERCY
GTO's
A & M Studio
Los Angeles, Nov 1968

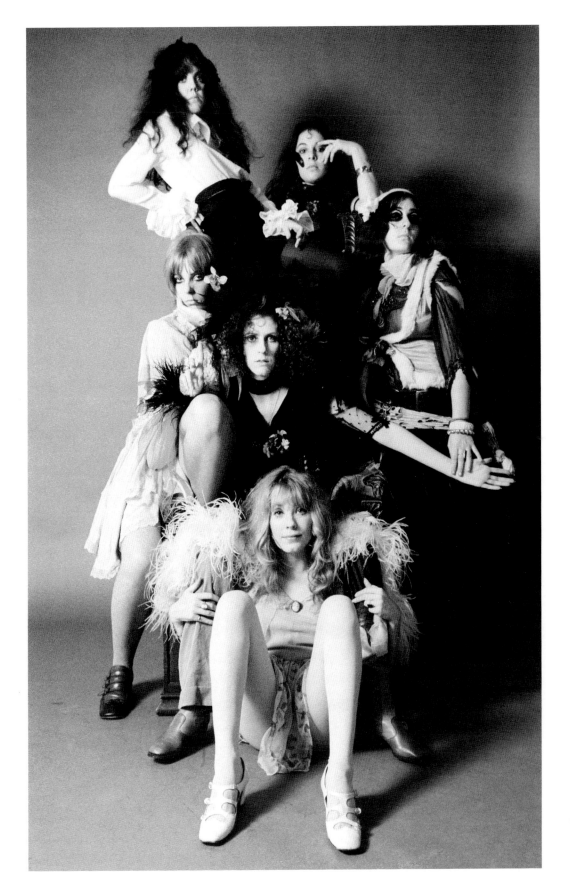

GTO's
A & M Studio
Los Angeles, Nov 1968

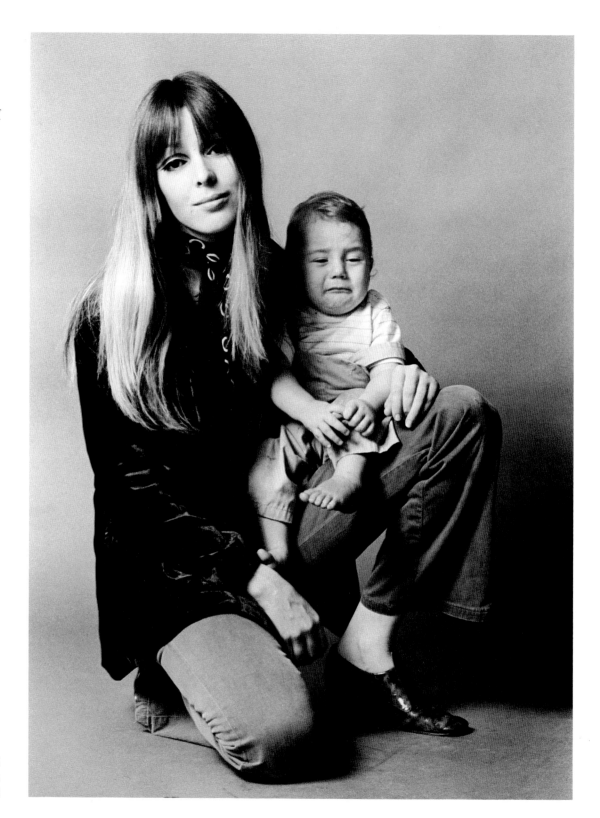

CATHERINE JAMES & SON
A & M Studio
Los Angeles, Nov 1968

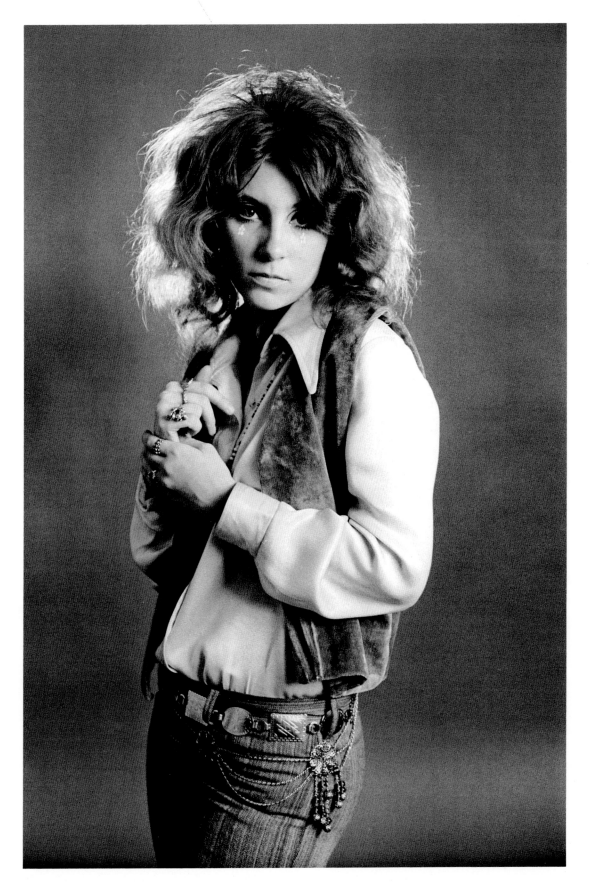

SALLY MANN
Belvedere St. studio
San Francisco, Nov 1968

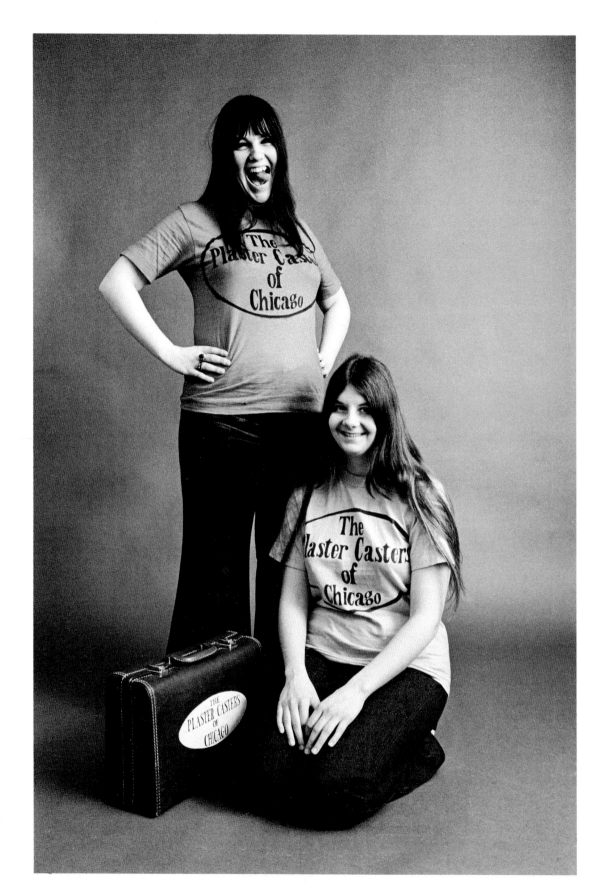

CYNTHIA & DIANNE

*The Plaster Casters
of Chicago
Michael Mauney Studio
Chicago, Jan 1969*

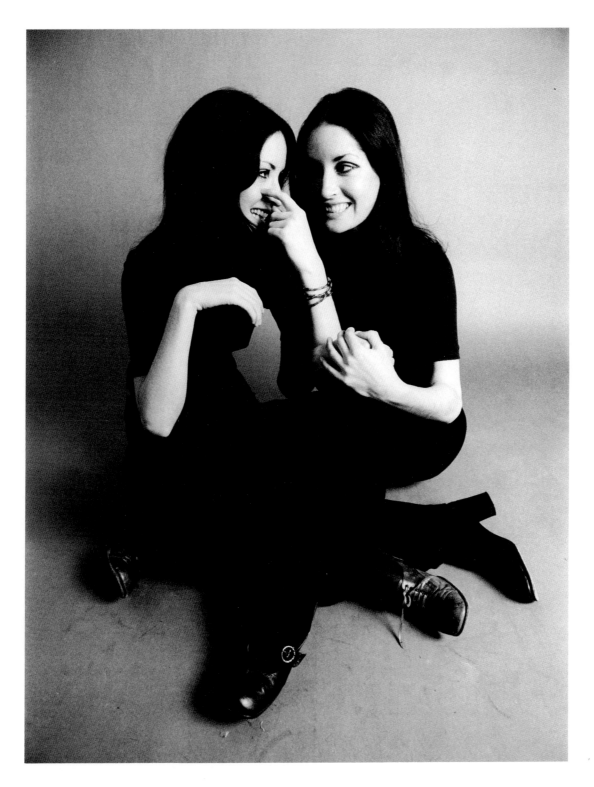

THE SANCHEZ TWINS
Belvedere St. studio
San Francisco, Nov 1968

FESTIVALS

WHEN MY FRIEND—the talented photographer, Jim Marshall—and I set out in the spring of 1969 to document a series of American music festivals, Woodstock was not on our itinerary. But at midsummer the list of scheduled musicians sounded intriguing. By the end of our tour, descriptions of the gathering on Yasgur's farm in upstate New York had reached mythical proportions. ● It had been a singular encounter, at once terrifying and exhilarating: 300,000 souls locked into a rock and roll mind dance with the music and with each other. For three days, calmed by a well of affection among strangers, a gathering the size of a respectable city watched and listened and celebrated. So much could have gone wrong; so little did. So much went right; suddenly dreams seemed attainable. There were other wonderful festivals that summer, but only one Woodstock. ● If not for the blues, there would be no rock and roll. On its 150th birthday, the city of Memphis celebrated these musical roots. In the Overton Park bandshell the originals gathered: Mississippi Fred McDowell, Bukka White, Johnny Woods, Furry Lewis, Sleepy John Estes. At the Memphis Country Blues Festival, and later that summer at the Ann Arbor Blues Festival, the crowd came more for the music than the scene, and if you wanted to experience firsthand the artistry of "the troubadours of the first truly American music," these were the concerts to attend. ● It was also the music that drove the Newport Folk Festival. On its own tenth anniversary, Newport eschewed amplified electric sound for the quiet and subtle tones of the acoustic guitar. While the astronauts were walking on the moon and the headliners performed onstage, hundreds of young musicians attended festival workshops or sat around on the grass of Freebody Park, happily strumming for tiny, appreciative audiences. ● At a New Mexico "sympowwowsium" in October of 1969, the topic was "the architecture of mass gatherings." What would come after Woodstock, everyone wondered—a questioned answered two months later at Altamont. No one should have died that day, for the Woodstock experience proved that disaster could be avoided by adherence to a few simple guidelines, laid out at the symposium: "No exterior authority. Don't try to stop any situation—reorient the energy being expended, put that energy to work. Grace as opposed to efficiency; the mood determines the situation, not the rule." When we gather to celebrate, music and unity blend into a harmonious experience. ● John Carpenter, music editor of the *Los Angeles Free Press*, explained, "You've got to have outdoor concerts and festivals. Everybody wants to be free for a day, to run around and be free. People come together and they don't wear their hang-ups for once. They don't hassle each other; they are inordinately kind. Festivals are good soundtracks for the movies we're making inside our heads."

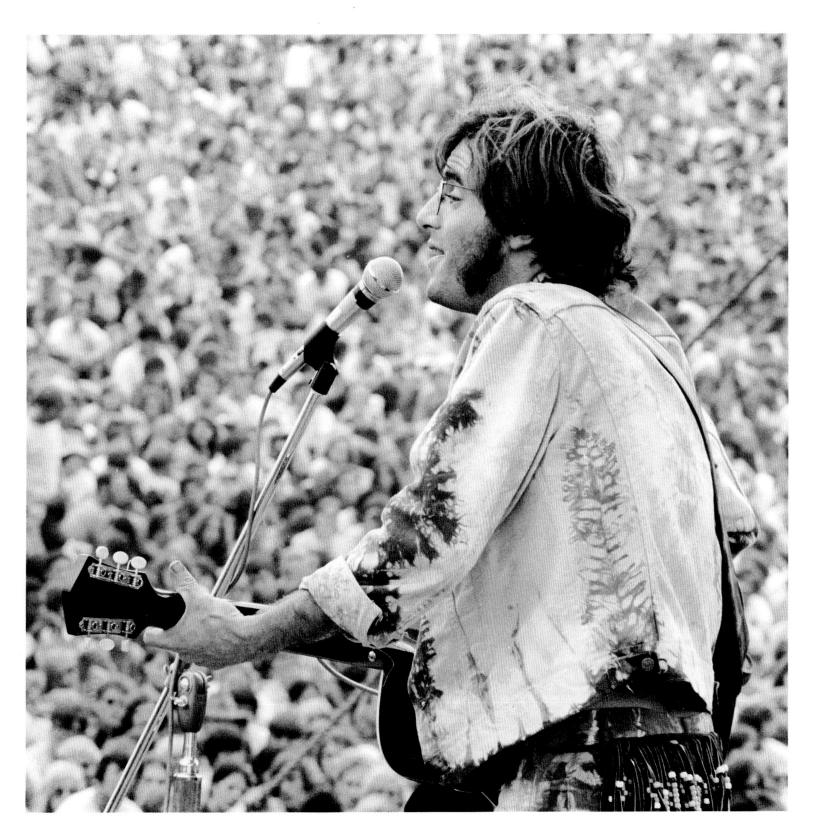

JOHN SEBASTIAN *Lovin' Spoonful, Woodstock Festival, Aug 1969*

ON YASGUR'S FARM
Woodstock Festival
Aug 1969

EAT AND TOKE *Woodstock Festival, Aug 1969*

300,000 STRONG *Woodstock Festival, Aug 1969* →

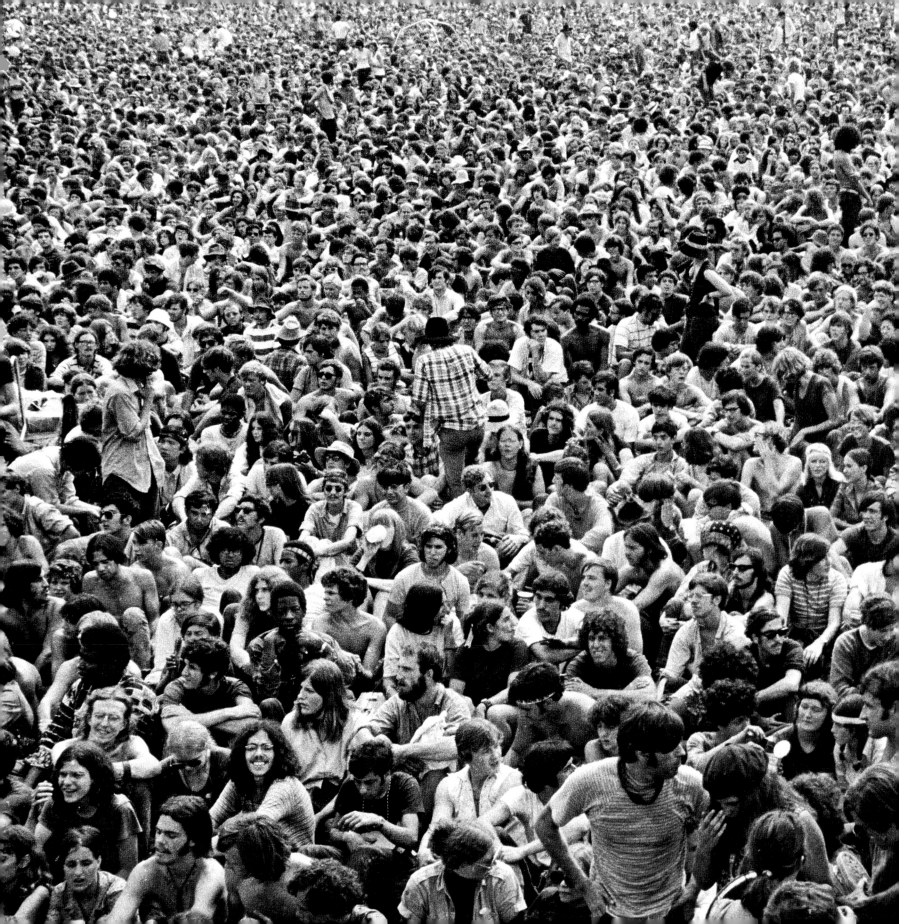

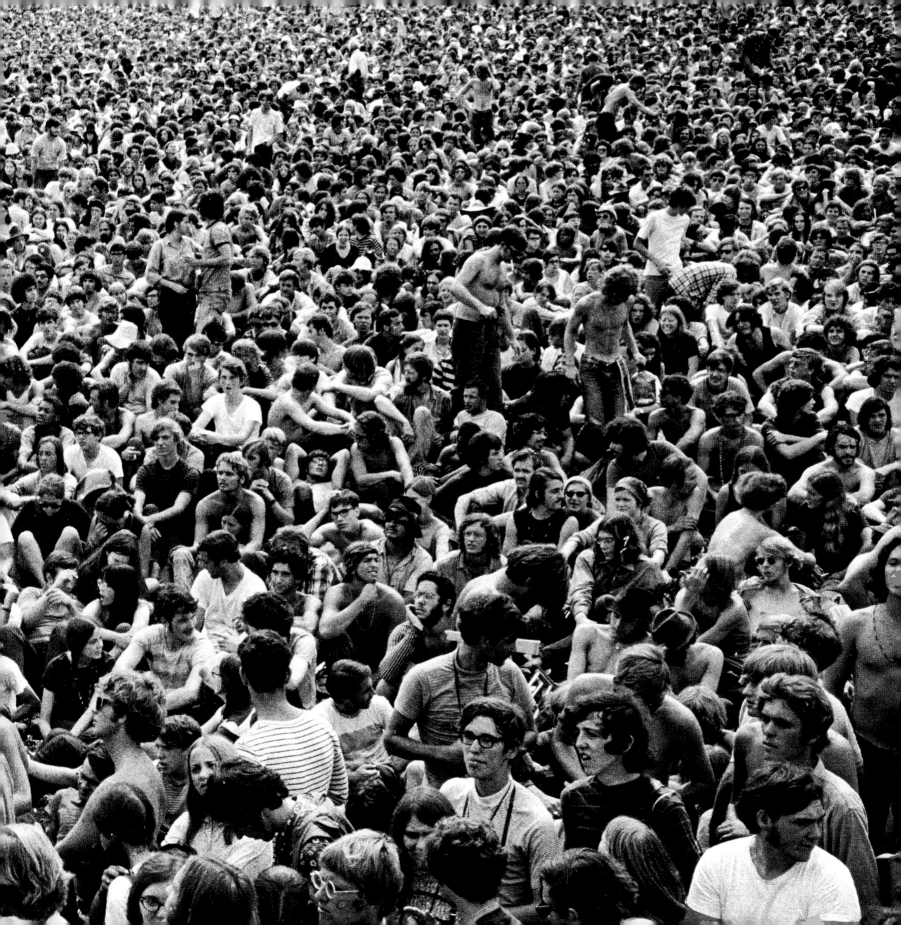

NATIONAL GUARD MEDIVAC HELICOPTER *Woodstock Festival, Aug 1969*

One Week's Dead from Life Magazine *Big Sur Folk Festival, Sep 1969*

MORNING AT WOODSTOCK, NEW YORK *Aug 1969*

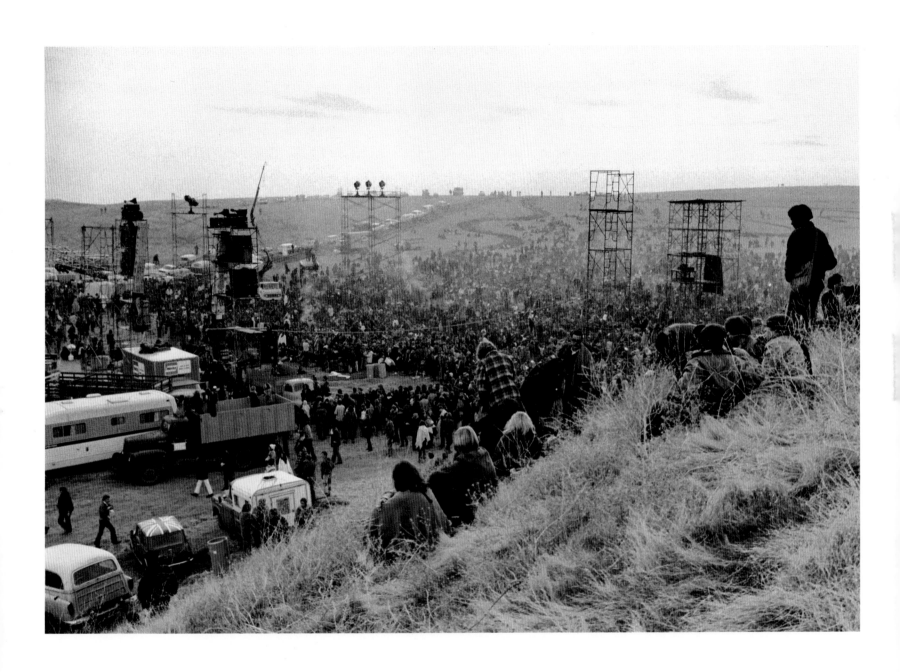

Morning at Altamont, California *Dec 1969*

JAMES TAYLOR
Newport Folk Festival
Rhode Island
July 1969

VAN MORRISON
Newport Folk Festival
Rhode Island
July 1969

JOHNNY WINTER
Memphis Country
Blues Festival
Tennessee
June 1969

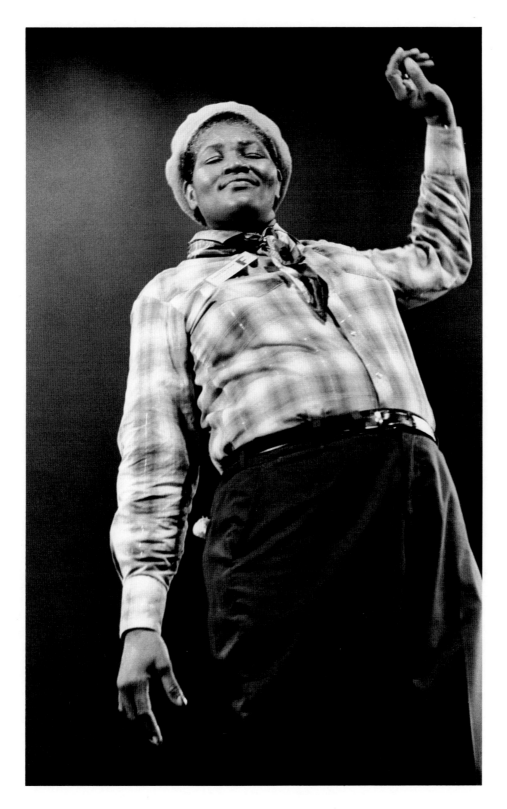

WILLIE MAE "BIG MAMA" THORNTON
Newport Folk Festival
Rhode Island
July 1969

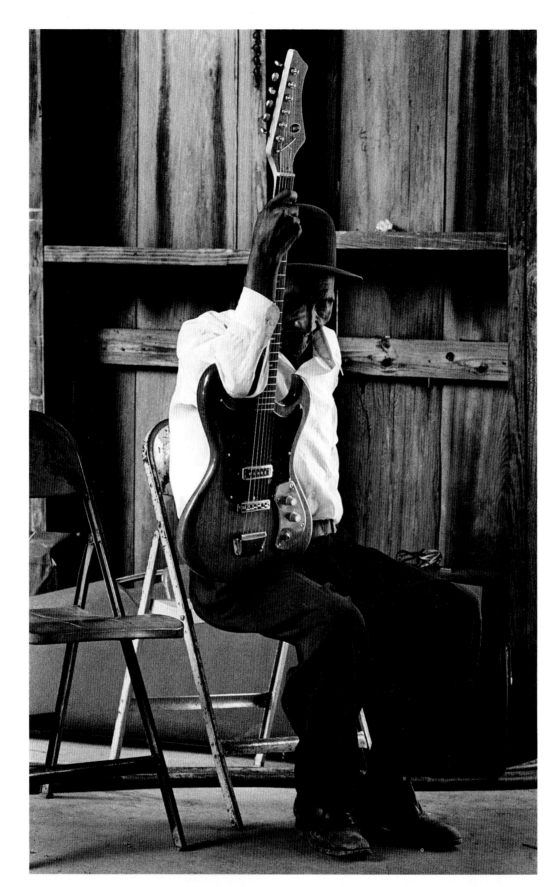

NATHAN BEAUREGARD
Blind bluesman, Age 106
Memphis Country
Blues Festival
Tennessee
June 1969

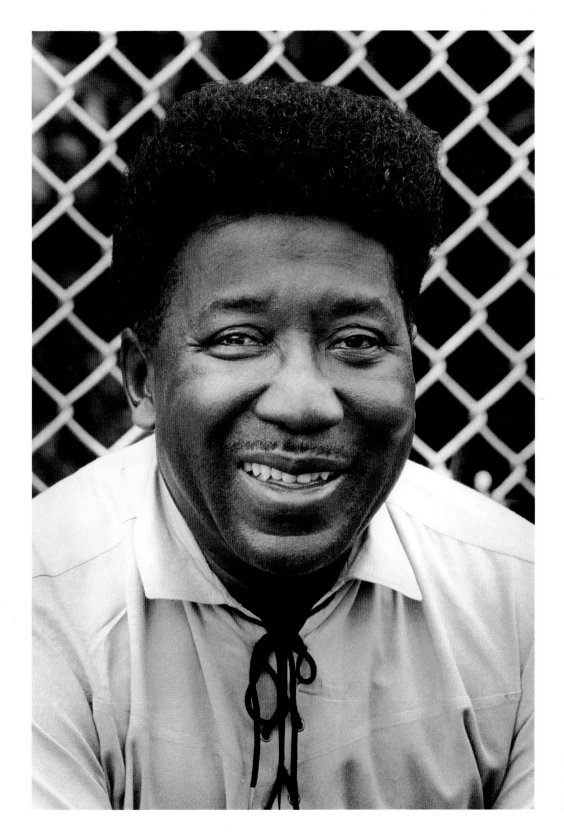

MUDDY WATERS
Ann Arbor Blues Festival
Michigan
Aug 1969

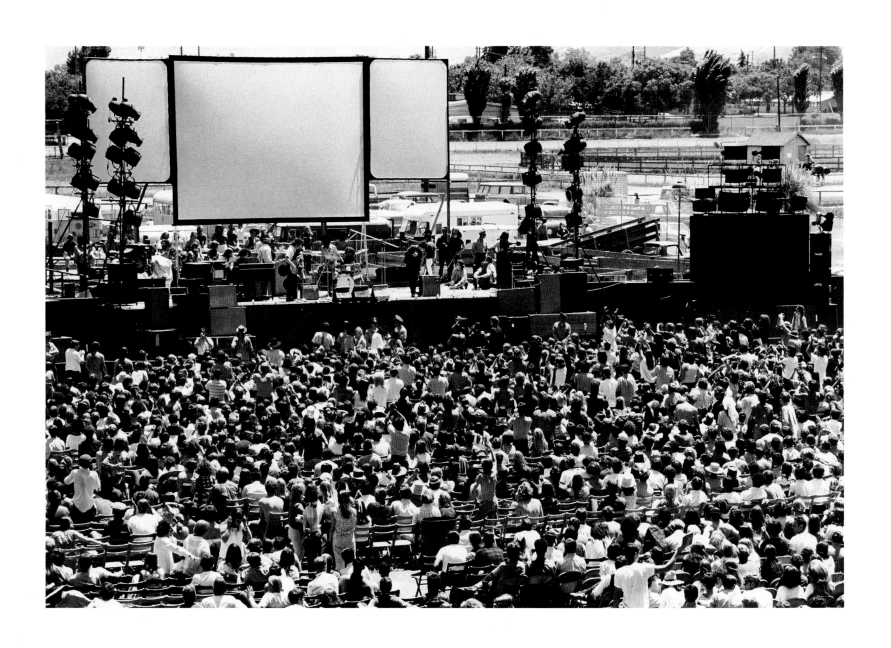

NORTHERN CALIFORNIA POP FESTIVAL *San Jose, May 1969*

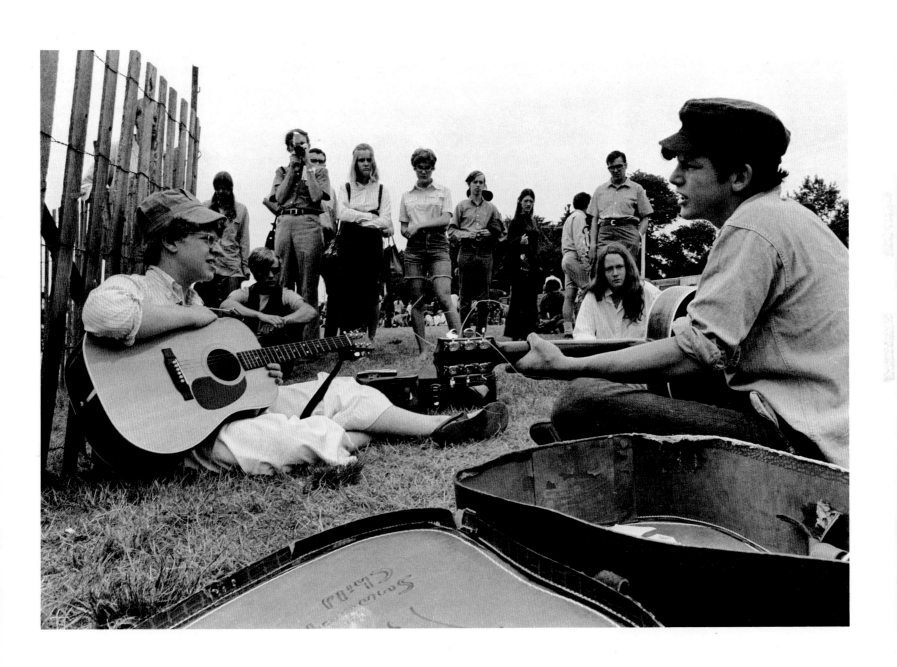

STRUMMIN' AND PICKIN' *Newport Folk Festival, Rhode Island, July 1969*

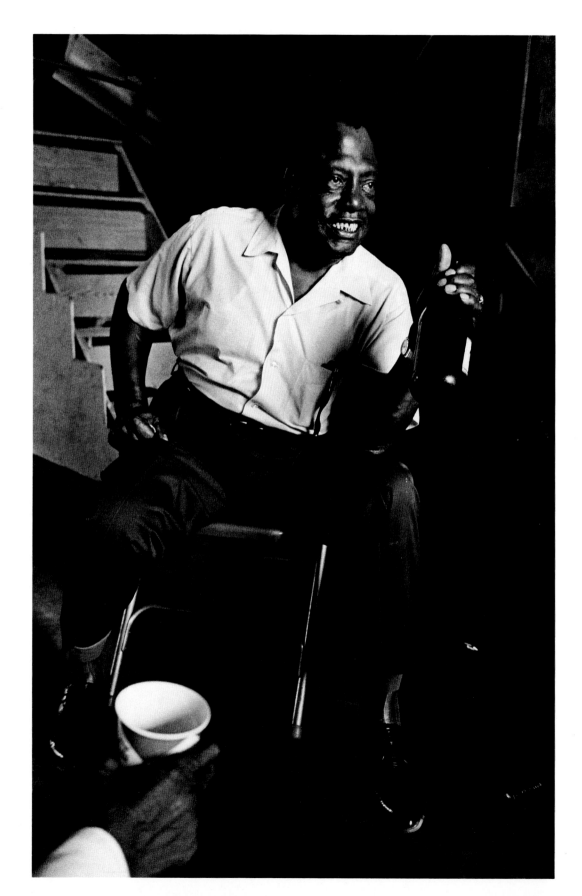

BUKKA WHITE

Memphis Country
Blues Festival
Tennessee
June 1969

MISSISSIPPI FRED MC DOWELL

Memphis Country
Blues Festival
Tennessee
June 1969

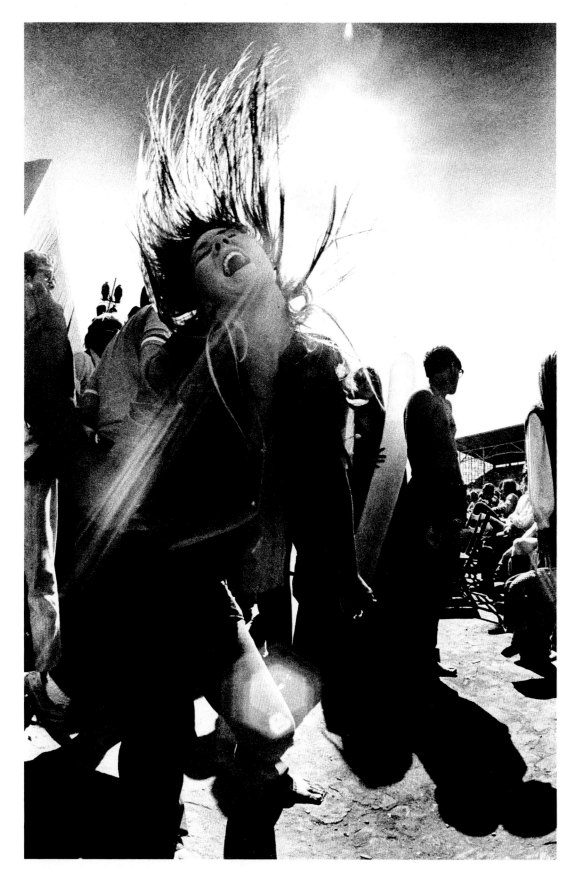

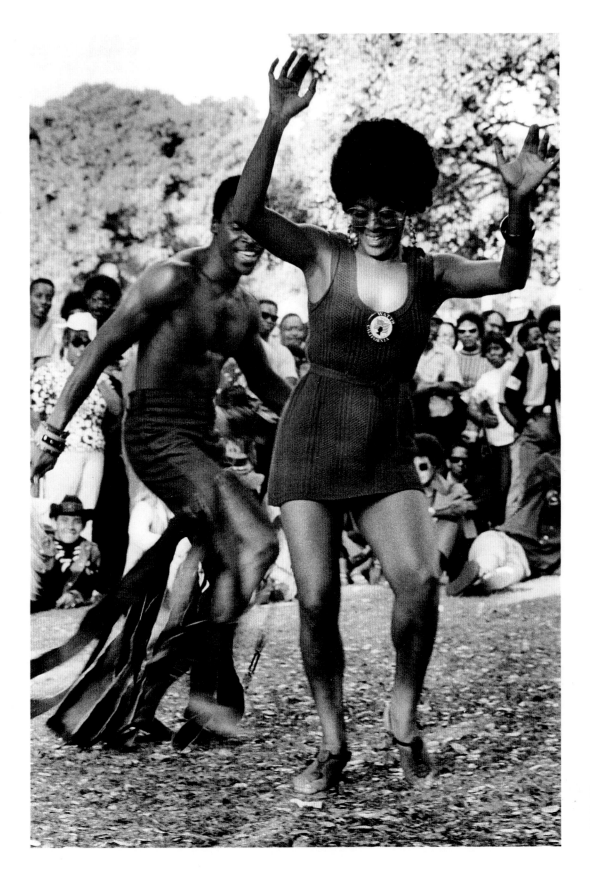

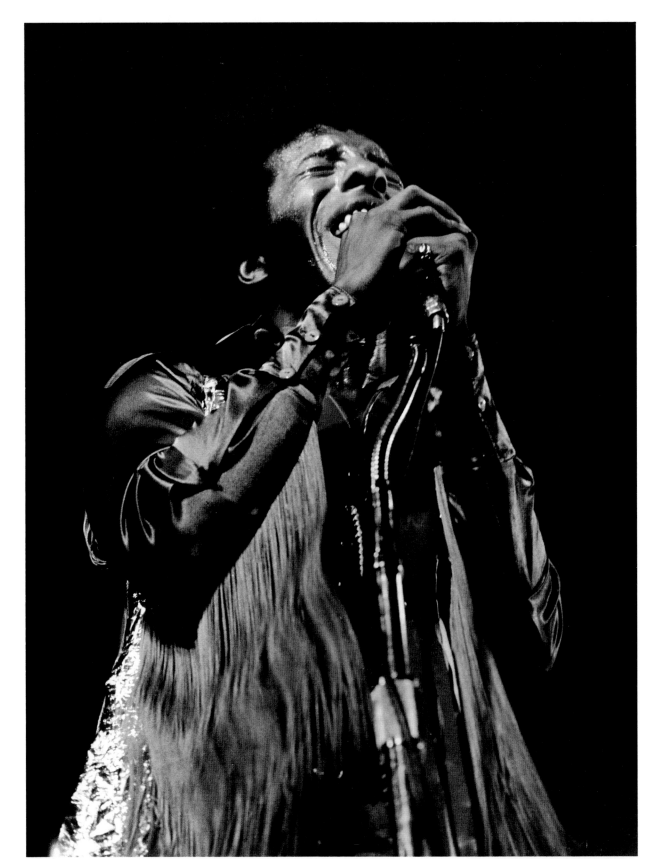

SLY STONE

Sly & the Family Stone
Monterey Jazz Festival
California
Sep 1969

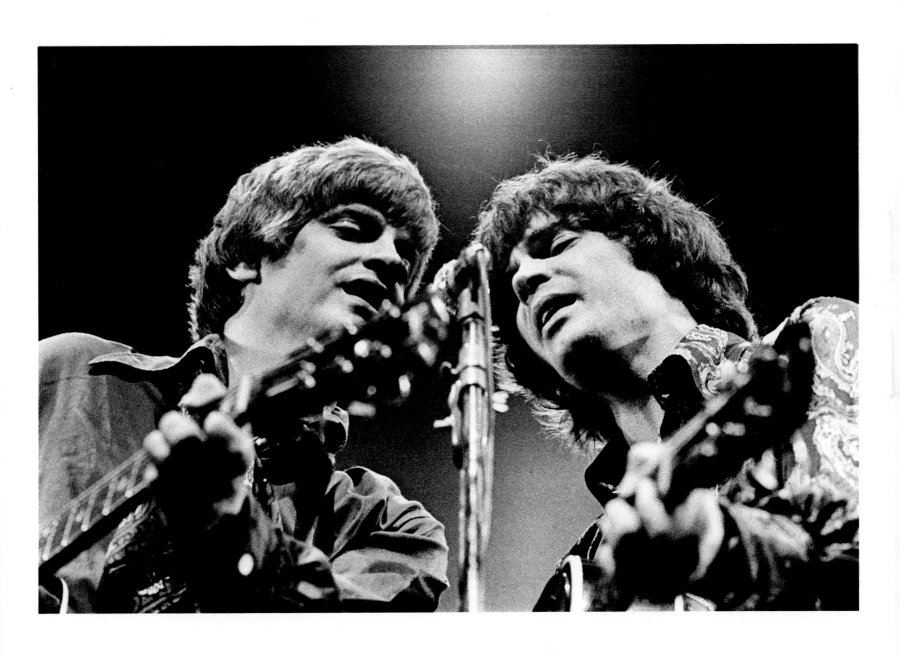

EVERLY BROTHERS *Newport Folk Festival, Rhode Island, July 1969*

A COLOR ALBUM

BLACK AND WHITE was the film of choice in 1967. It was still expensive to publish color photographs. Technology had yet to bring color pictures into newspapers, and *Rolling Stone* was every bit a newspaper, printed on newsprint by an aging press. ● Which is not to say the Sixties were not colorful. They were, in every sense of the word. But the editorial market for pictures was predominately black and white, and we photojournalists were in the picture marketing business. What good were great color photographs if nobody could see them? So we loaded our Nikons and Leicas mostly with Kodak's dependable Tri-X and concentrated on shape and form, only occasionally documenting the rainbow hues of the times. Record companies used color for album covers and the big New York magazines printed color on their slick glossy pages. ● It is not just a question of film, however. Photographers actually "see" differently in black and white than in color. There is no color spectrum in black and white, just shades of gray, shadows and highlights. In the purity of monochrome, communication is much more dependent upon content. Color film brings another dimension to the image; color relationships become a new concern. New technical issues emerge: hardware, light sources, emulsions and film speeds. ● Some subjects simply demand color. Without it the striking stage sets of Bill Graham's Day-on-the-Green concerts would be dull. Without color, Wayne Cochran's suit by Nudie loses its character, B.B. King's guitar, Lucille, loses her personality, and Fats Domino's red velvet pants are lost completely. ● But color alone does not make a better picture. Adding color to black and white, for example, is not necessarily an improvement. Colorized movies may seem more familiar, yet their origins cannot be disguised. They invariably have an unnatural quality, no matter how successful their computer-enhanced metamorphosis. ● Hand-coloring, on the other hand, is a true art form. One layer of creativity is applied upon another to form a third. While the pictures of Jimi Hendrix, Jim Morrison, Steve Miller, Frank Zappa and Tina Turner have been altered, the essence of the photographs was not compromised when color was applied to them. They now represent a new, enhanced vision of the same subject. ● Successful photography is ultimately not a question of color versus black and white, but one of content and communication. Janis Joplin in color tells us something about her whimsical sense of style. Janis Joplin in black and white gives us her soul. The camera simply transforms facts into opinions, super-star photographer Richard Avedon explains. "There is no such thing as inaccuracy in a photograph; all photographs are accurate. None of them is the truth."

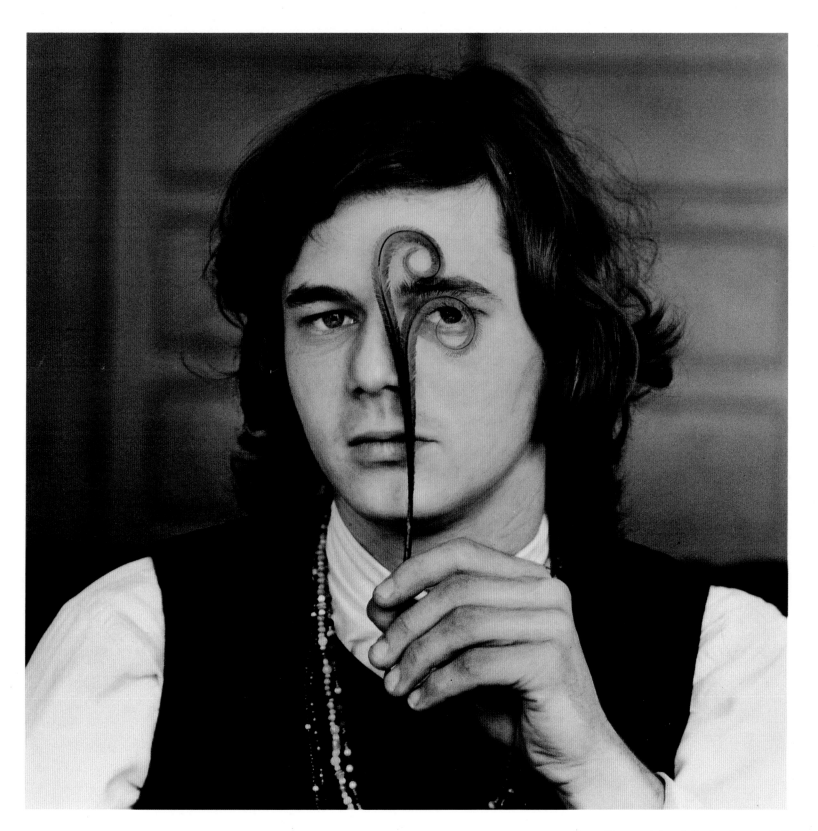

STEVE MILLER *At home in San Francisco, Nov 1967*

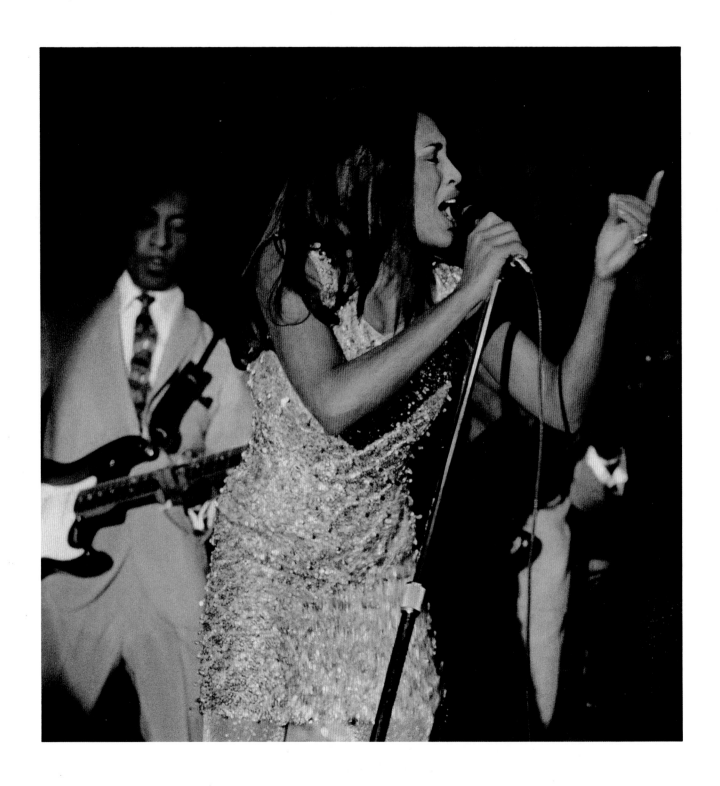

TINA TURNER WITH IKE *The hungry-i, San Francisco, Oct 1967*

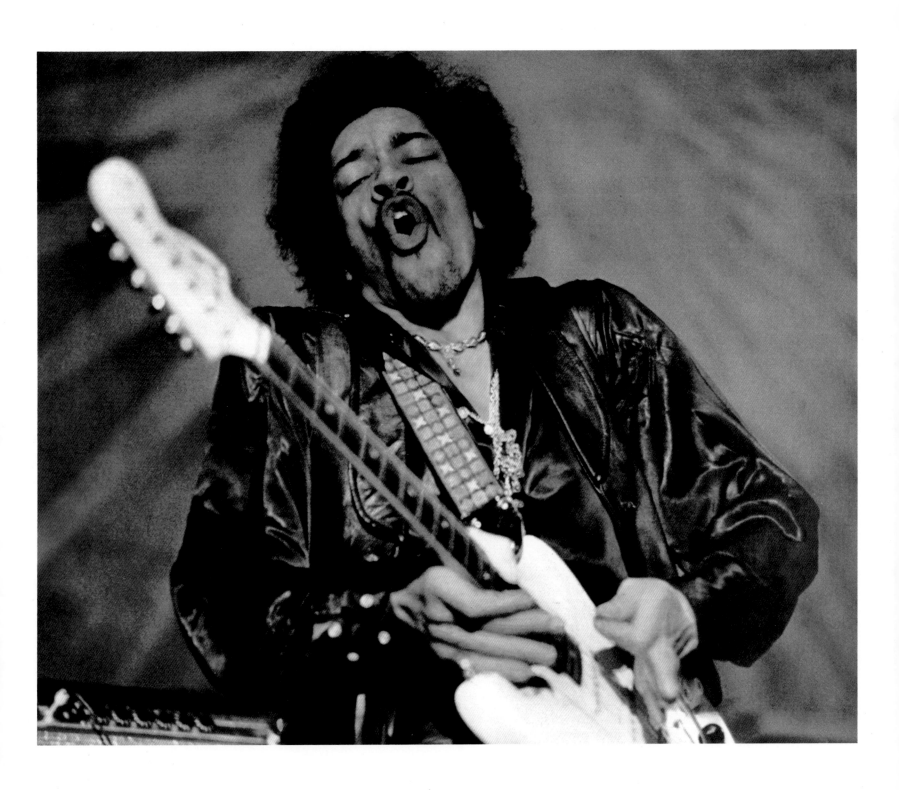

JIMI HENDRIX *Fillmore Auditorium, San Francisco, Feb 1968*

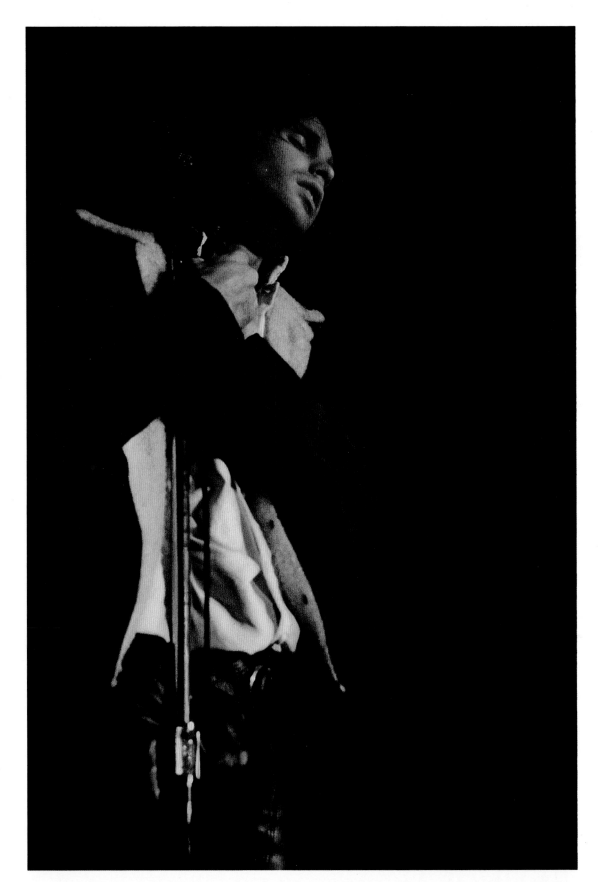

JIM MORRISON
Winterland
San Francisco
Dec 1967

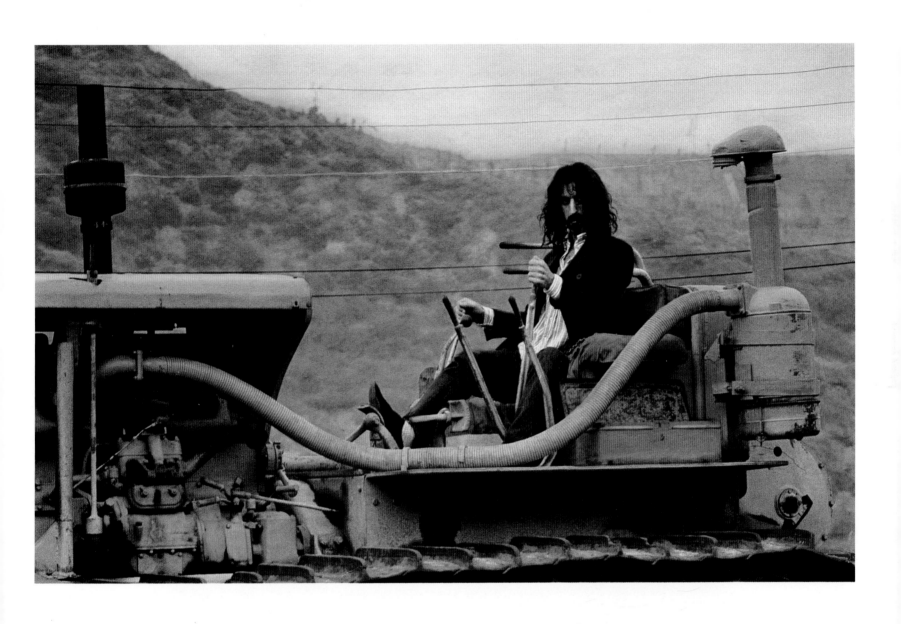

FRANK ZAPPA *Behind his Laurel Canyon home, Los Angeles, May 1968*

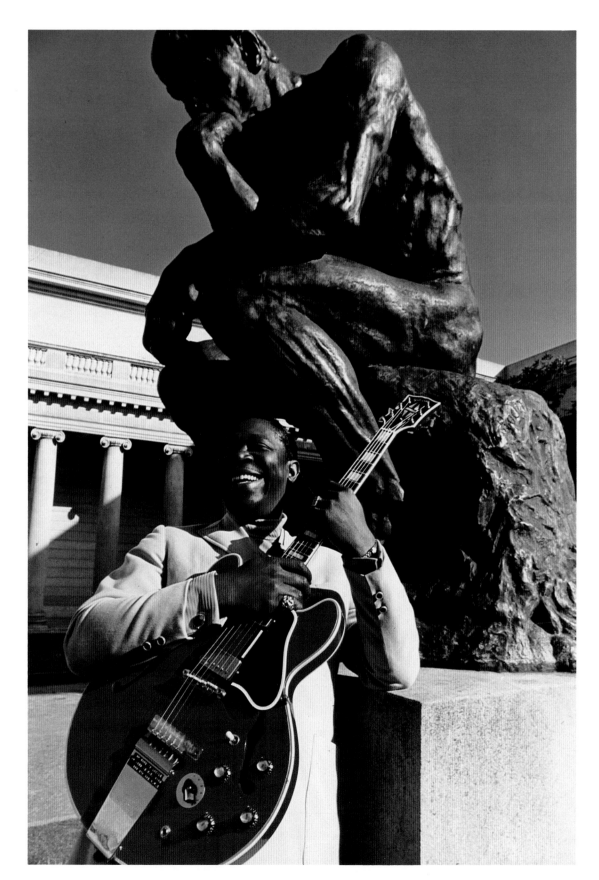

B.B. KING
Palace of the Legion of Honor
San Francisco
Dec 1967

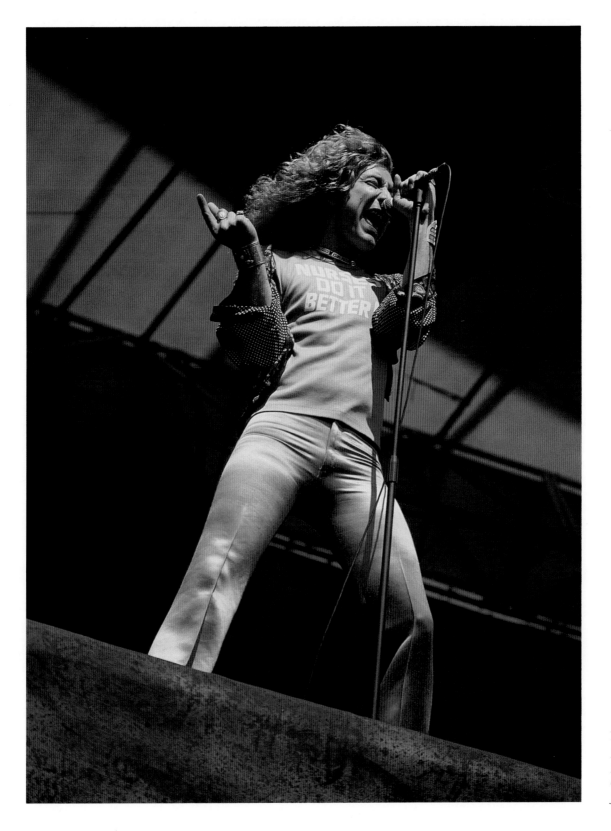

ROBERT PLANT
Led Zeppelin
Day-on-the-Green
Oakland Coliseum
July 1977

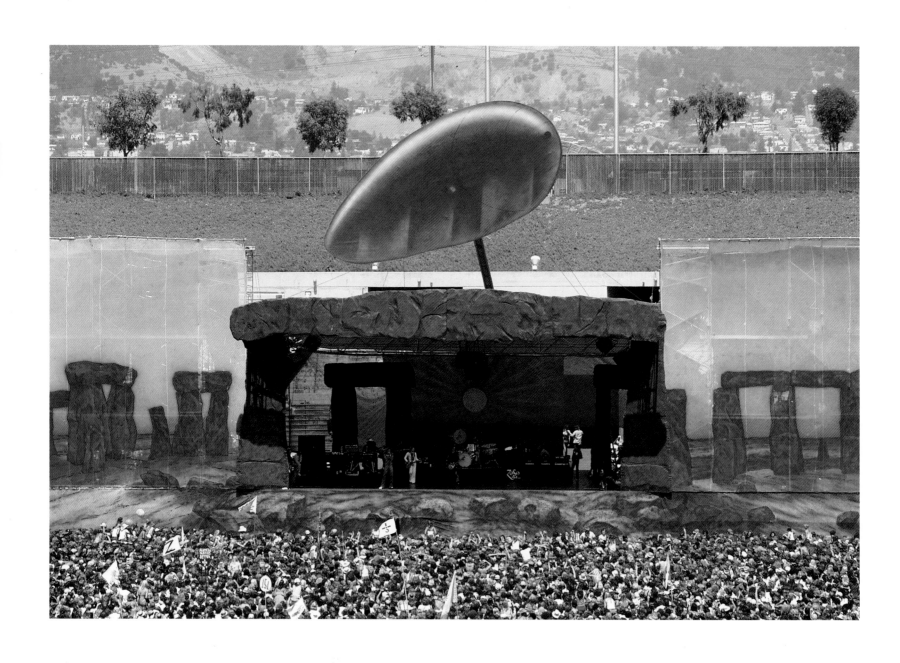

LED ZEPPELIN *Day-on-the-Green, Oakland Coliseum, July 1977*

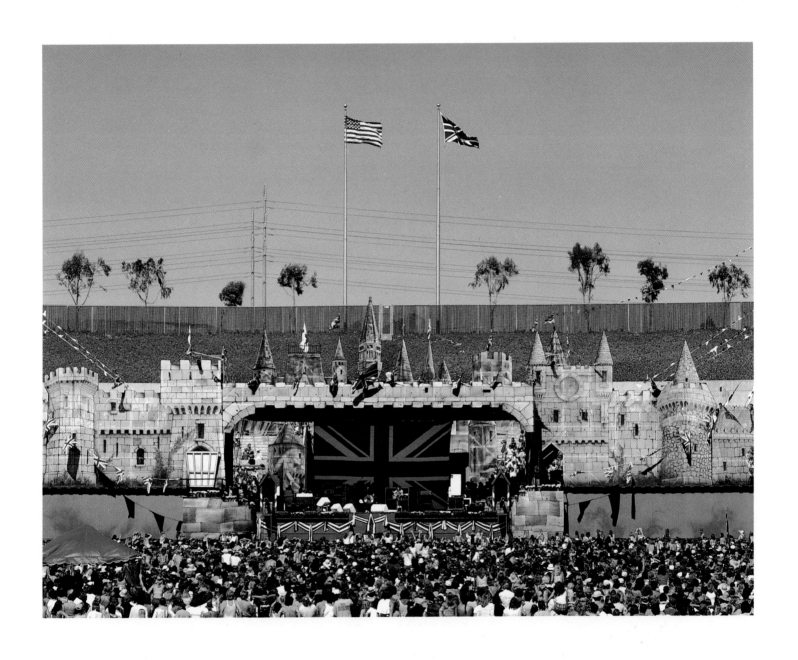

PETER FRAMPTON *Day-on-the-Green, Oakland Coliseum, July 1977*

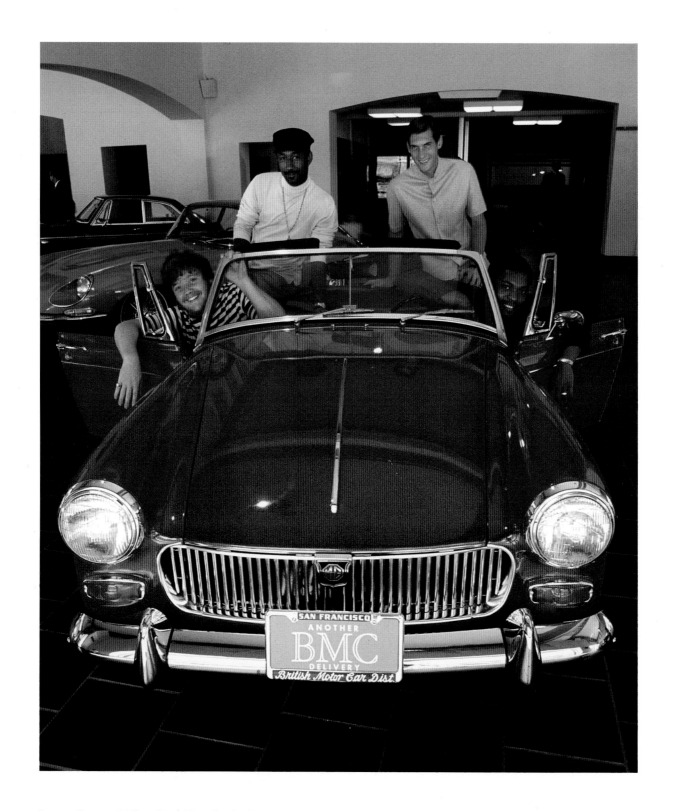

BOOKER-T & THE MG'S *British Motor Car Co., San Francisco, June 1968*

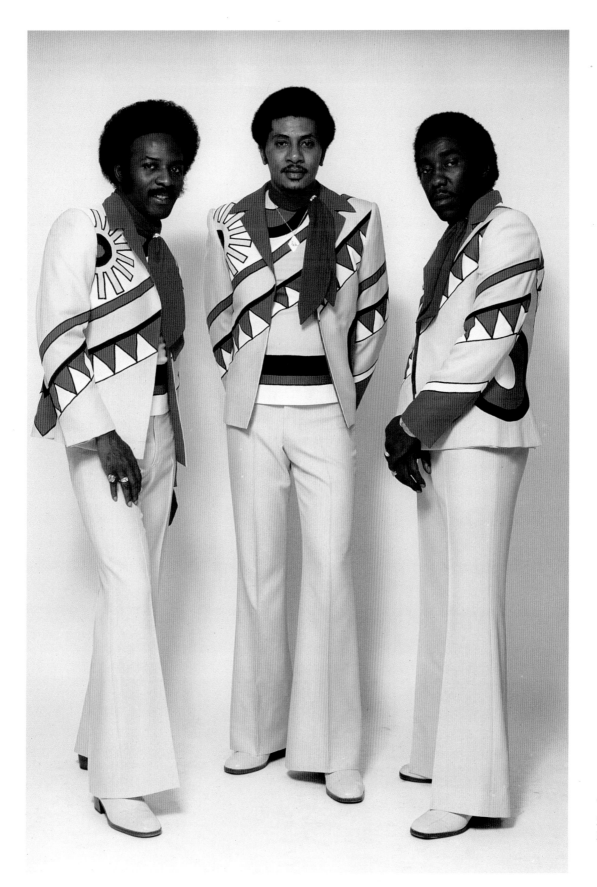

THE O-JAYS
Steven Frisch Studio
San Francisco, Sep 1975

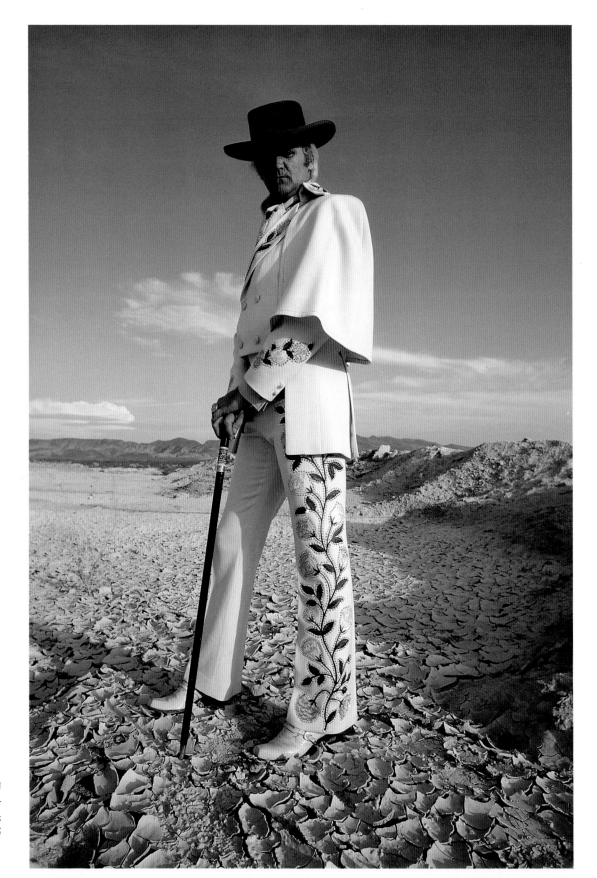

WAYNE COCHRAN
In the desert near
Las Vegas
Sep 1975

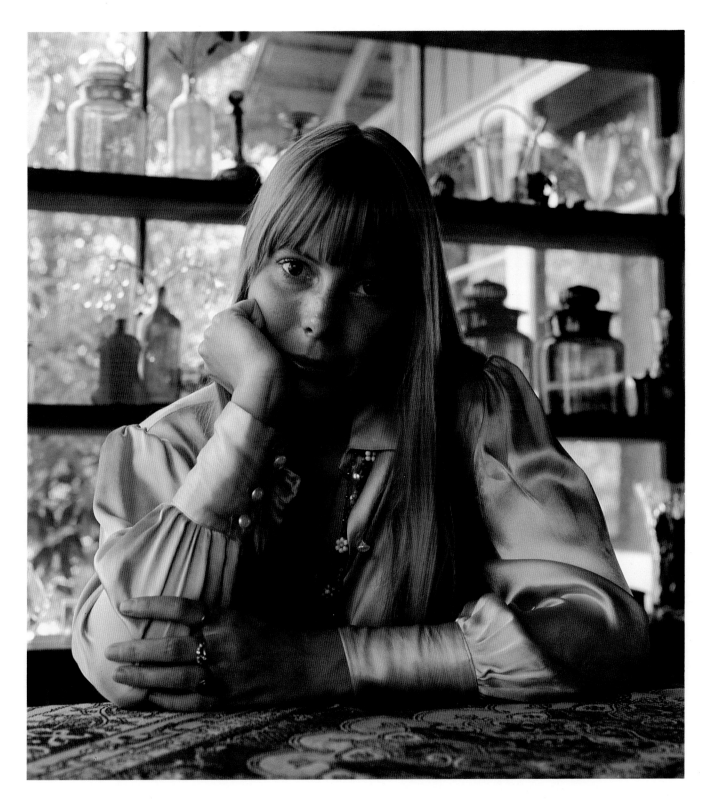

JONI MITCHELL *At home in Laurel Canyon, Los Angeles, Aug 1968*

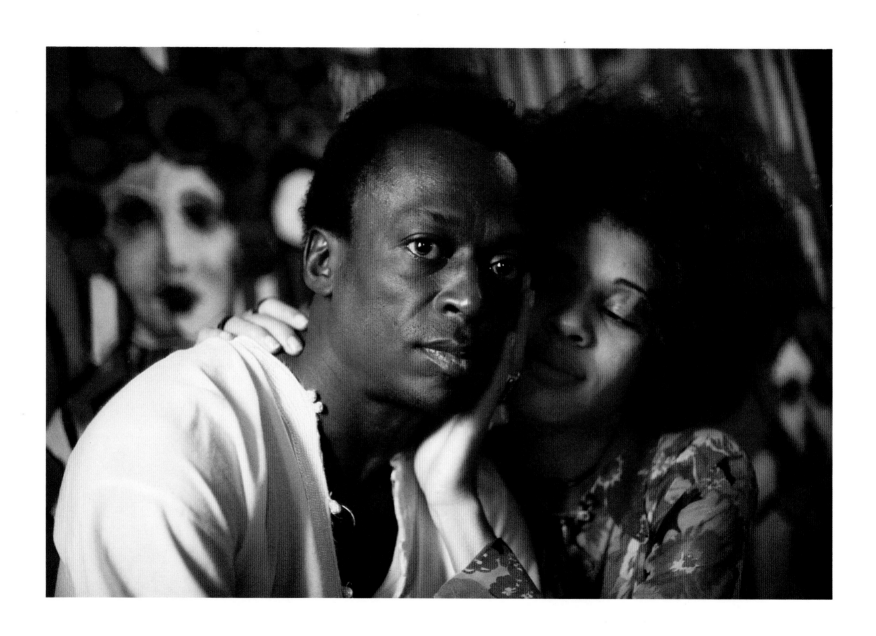

MILES DAVIS *With his then-wife Betty at home in New York City, Oct 1969*

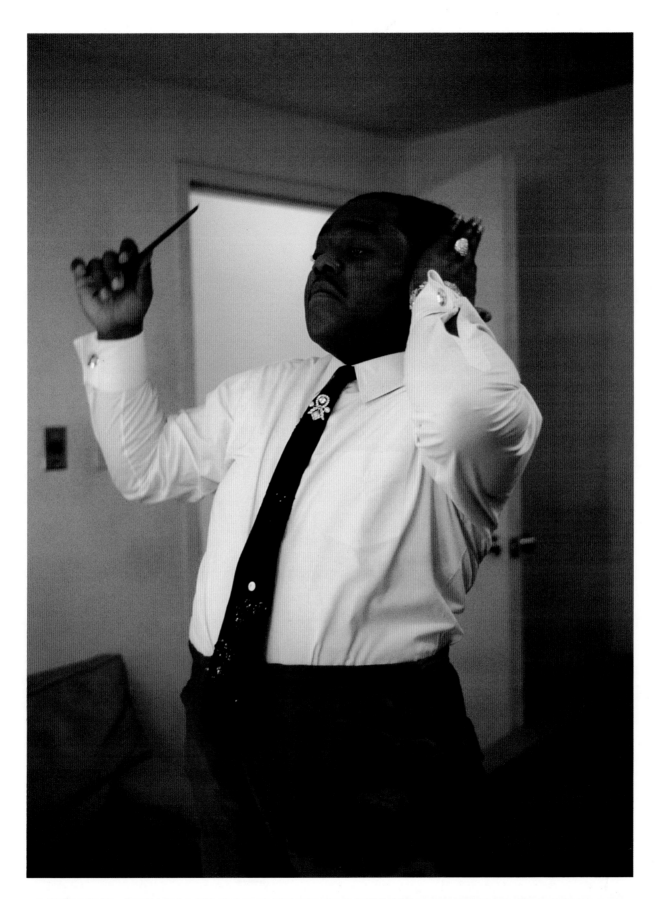

FATS DOMINO
Backstage
Las Vegas

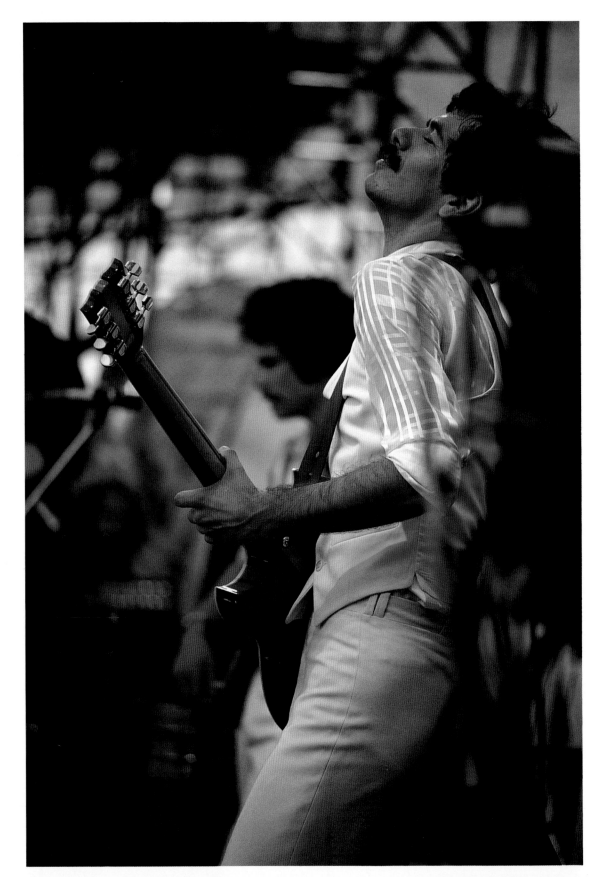

CARLOS SANTANA
Day-on-the-Green
Oakland Coliseum
July 1977

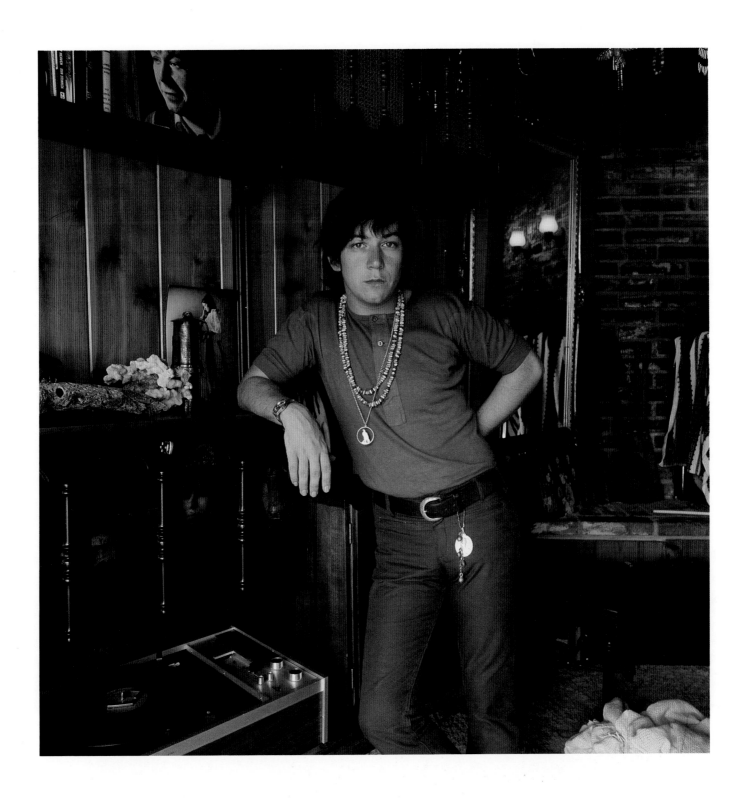

ERIC BURDON *At home in Los Angeles, Aug 1968*

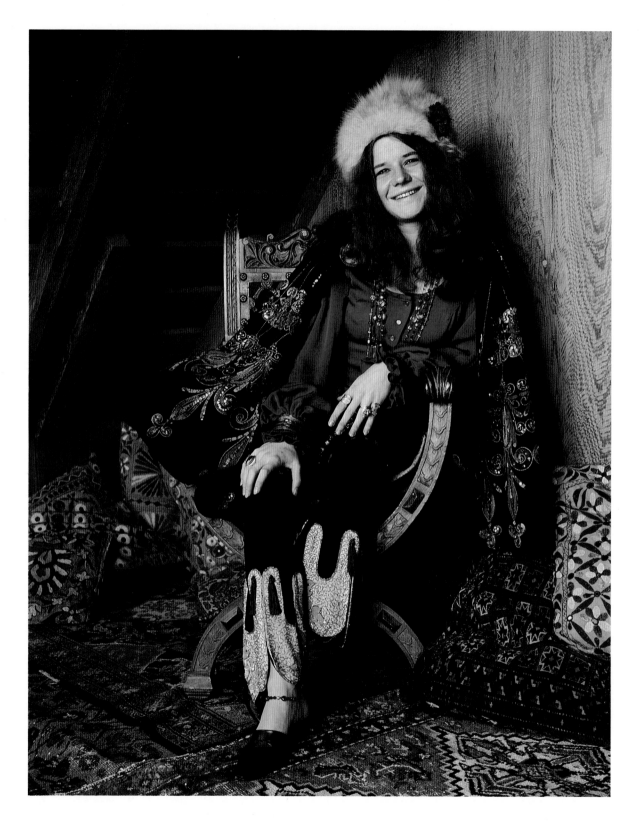

JANIS JOPLIN
Spaulding Taylor's house
San Francisco

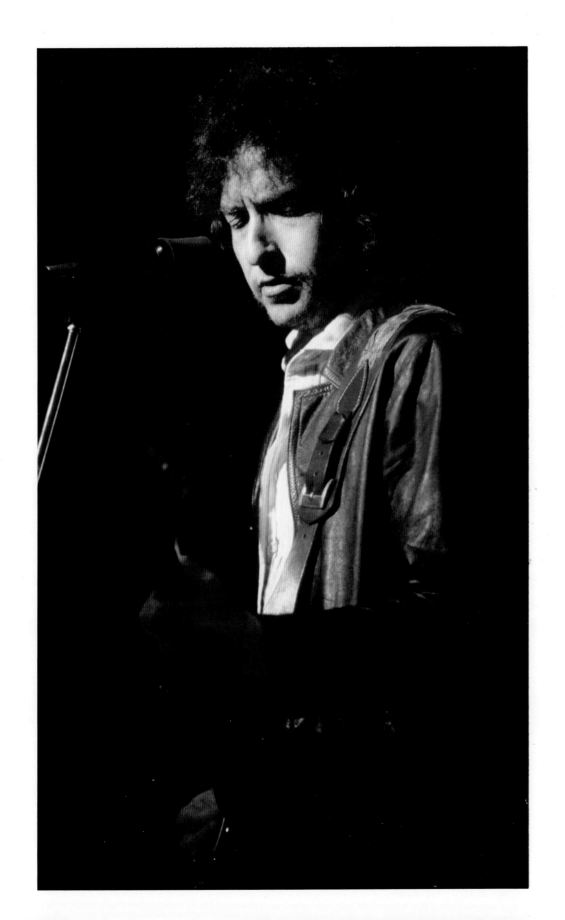

BOB DYLAN
Warfield Theatre
San Francisco, Nov 1979

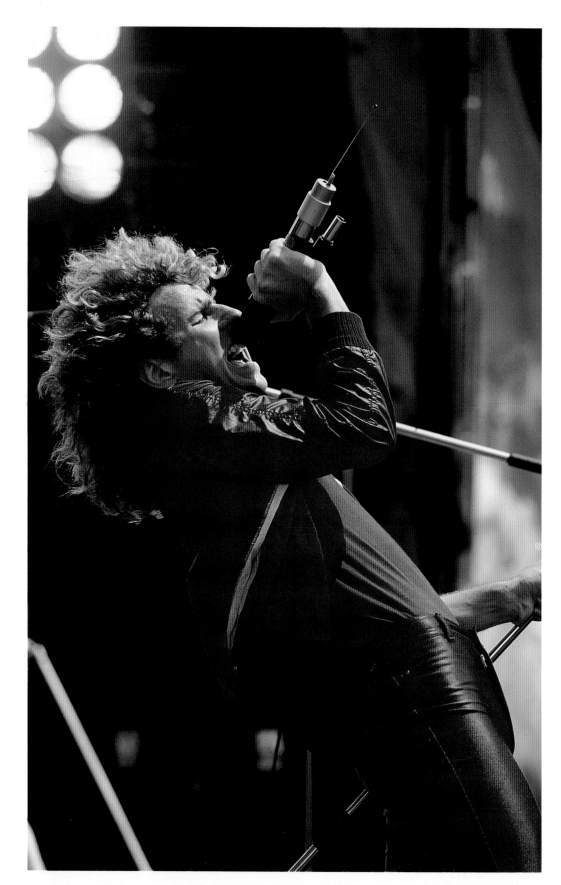

SAMMY HAGAR
Day-on-the-Green
Oakland Coliseum
May 1979

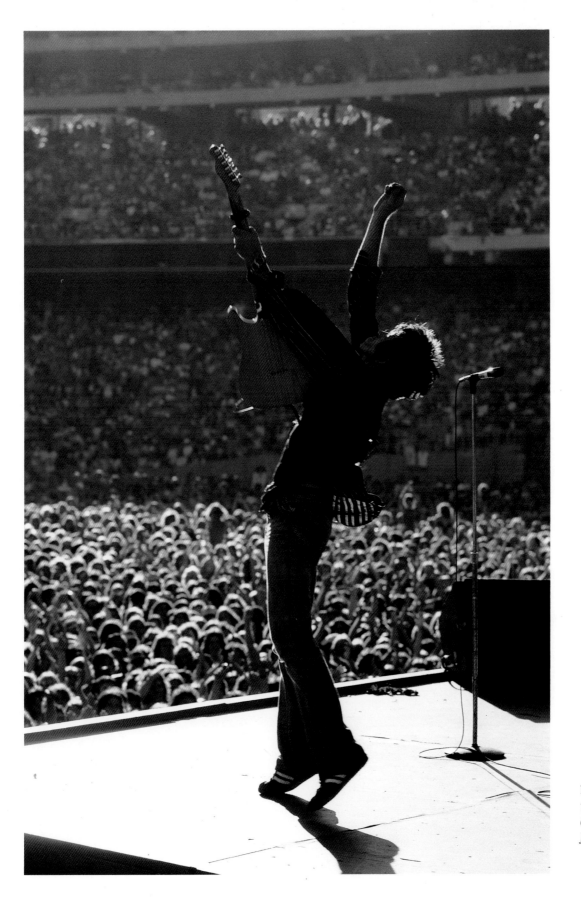

KEITH RICHARDS
The Rolling Stones
Oakland Coliseum
July 1978

OTHER ROLLERS

BILL GRAHAM was never on the cover of *Rolling Stone*, yet his contribution to the world of music was more than significant. He was flat out the industry's best rock promoter. He was also generous and compassionate, dedicated to a variety of social causes to which he gave his energy and his money. Following Graham's accidental death in late 1991, *Los Angeles Times* music critic Robert Hilburn recalled movingly that Graham had "found ways ... to believe in the goodness of man and in the soul-stirring celebration of art. Like so many of his generation, he lamented the loss in recent years of the sociological connection that existed between performers and fans in the 60s—the shared sense of optimism and social values. He thought that rock had become too much 'entertainment' and too little 'inspiration.' Unlike many of his peers, however, he didn't lose hope of regaining that connection." ● "Other Rollers" don't make music. They present concerts, they publish books and magazines, they write stories and poems, they create art, they preach, they dream. Some are Other Rollers simply by the clothes they wear or the words they speak, and some have been anointed by fate. In the fabric of the music scene, they are some of the threads, necessary but not sufficient. ● In May of 1968, we put the finishing touches on *Rolling Stone* issue Number 11. Jann had written a piece on country music featuring Johnny Cash, but none of the photos quite fit the cover. We had a rock and roll fashion piece, but none of those pictures were cover material either. The great backstage shot of a cigarette-smoking B.B. King would have looked terrific on the cover, but B.B. was not the lead story so that photo ran on page 18. In the end, an arbitrary choice would make *Rolling Stone* trivia history: the only cover that had nothing whatsoever to do with music or entertainment—a photograph, without a caption, of my then-wife Juliana. ● Ralph Gleason was a columnist for the *San Francisco Chronicle*, and one of the country's most respected music critics. He was also the co-founder of *Rolling Stone* and Jann Wenner's mentor. In 1967 both Gleason and Wenner believed that music mattered—mattered enough to cover professionally as journalists, mattered because music had emerged as the metaphor for the rapidly changing times. ● The result of this collaboration, of course, was *Rolling Stone*. For twenty-five years, with music as its catalyst, the magazine has told the story of America in transition. Some think it could have become America's most important magazine of that quarter century; some think it was. But certainly no publication looked better, no publication presented its stories with more excitement and fun, no publication told it straighter. ● In the end, all the controversies and opinions notwithstanding, *Rolling Stone* made a difference—to its readers, to its contributors, to its founders. And, like rock and roll itself, life would have been a lot less interesting without it.

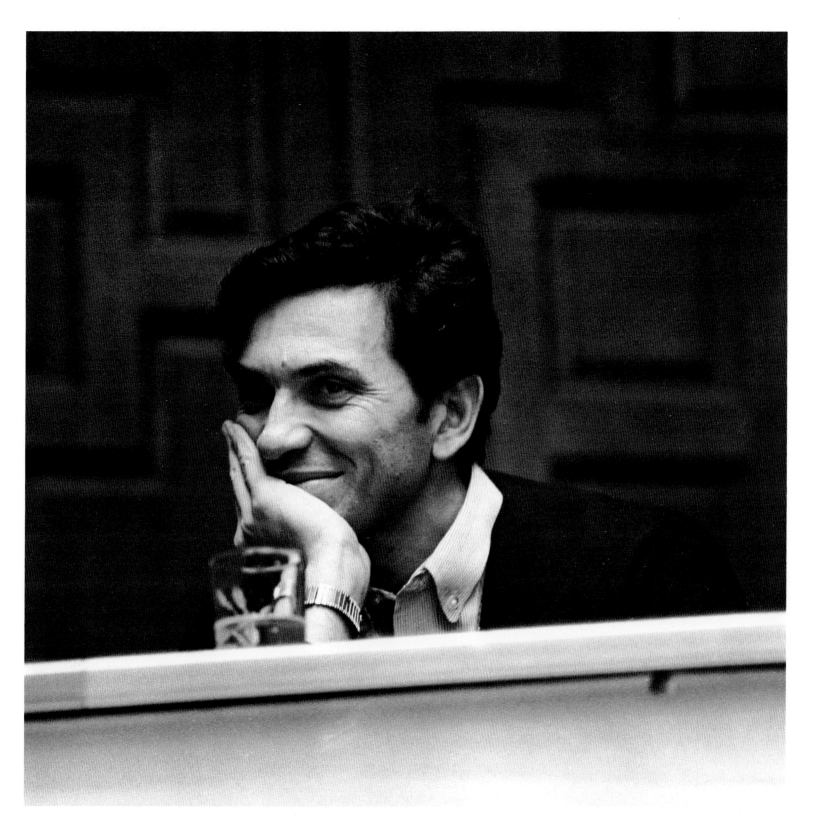

BILL GRAHAM *Mills College Conference on Rock & Roll, Oakland, Mar 1967*

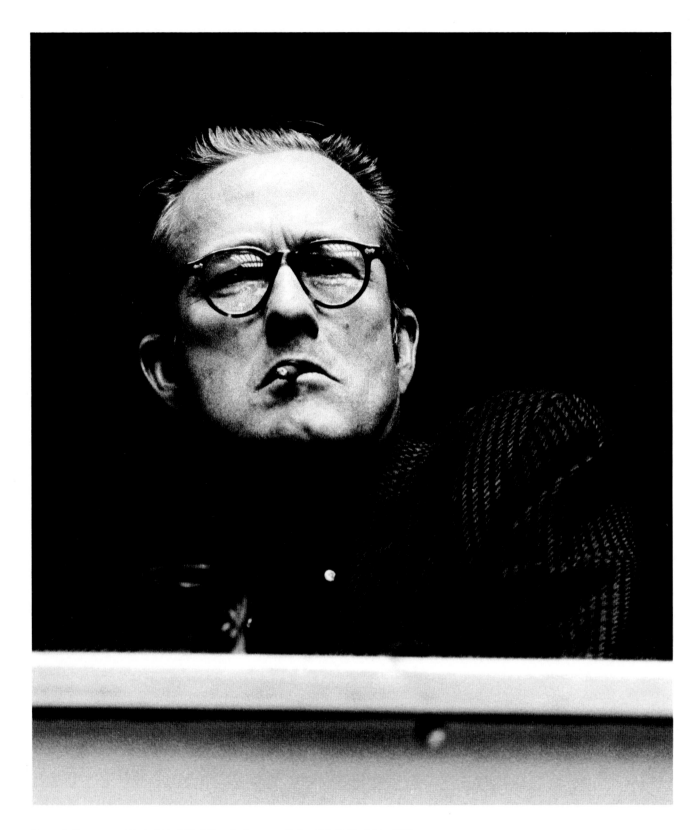

RALPH J. GLEASON *Music Critic, Mills College Conference on Rock & Roll, Oakland, Mar 1967*

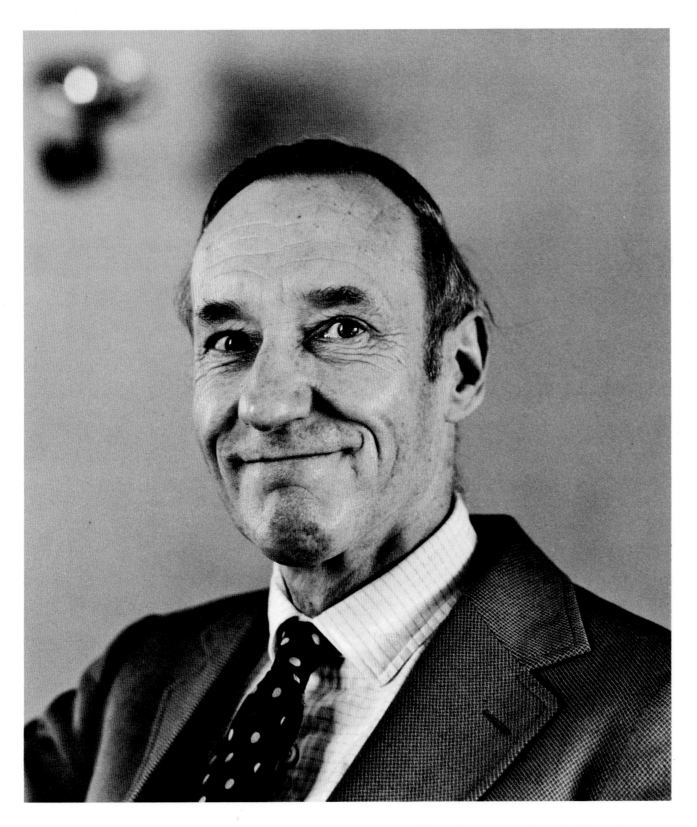

WILLIAM BURROUGHS *Author, in his flat, London, May 1970*

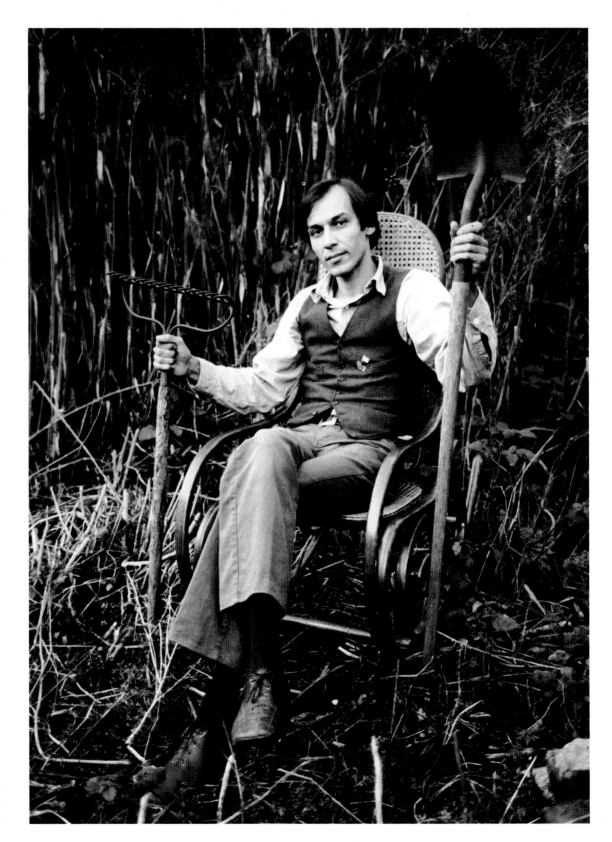

VICTOR MOSCOSCO
Poster Artist
Los Angeles, Nov 1968

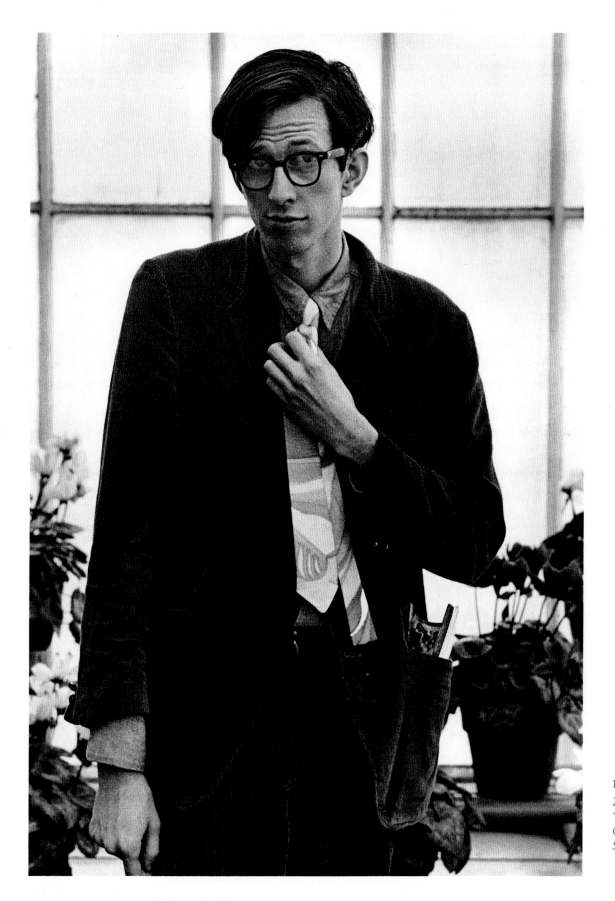

ROBERT CRUMB

Zap Comix
"Mr. Natural" Cartoonist
Golden Gate Park
San Francisco, Jan 1969

ROCK RADIO KMPX-FM STAFF *San Francisco, Oct 1967*

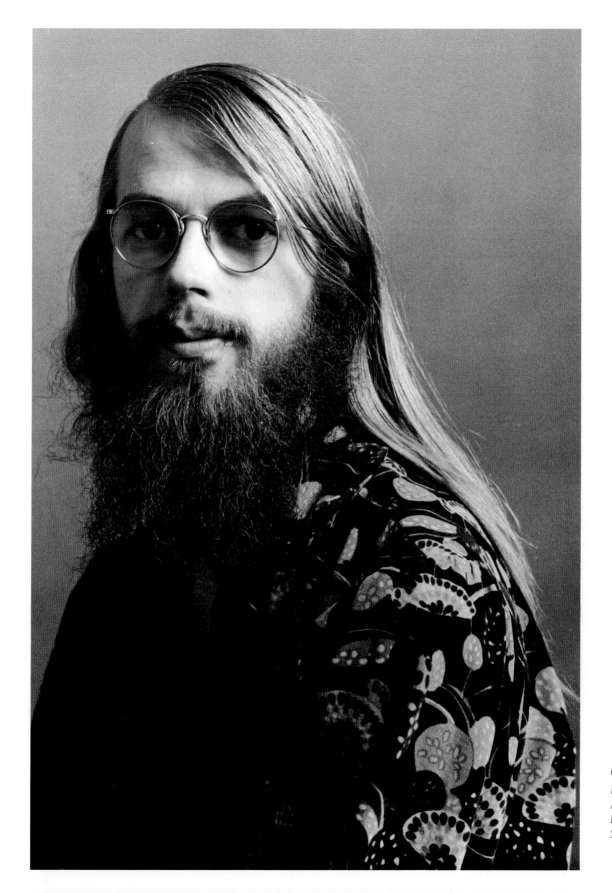

CHET HELMS
Family Dog's
Avalon Ballroom Manager
Belvedere St. studio
San Francisco, Nov 1968

HUGH "WAVY GRAVY" ROMNEY *Hog Farmer, Oakland, Oct 1969*

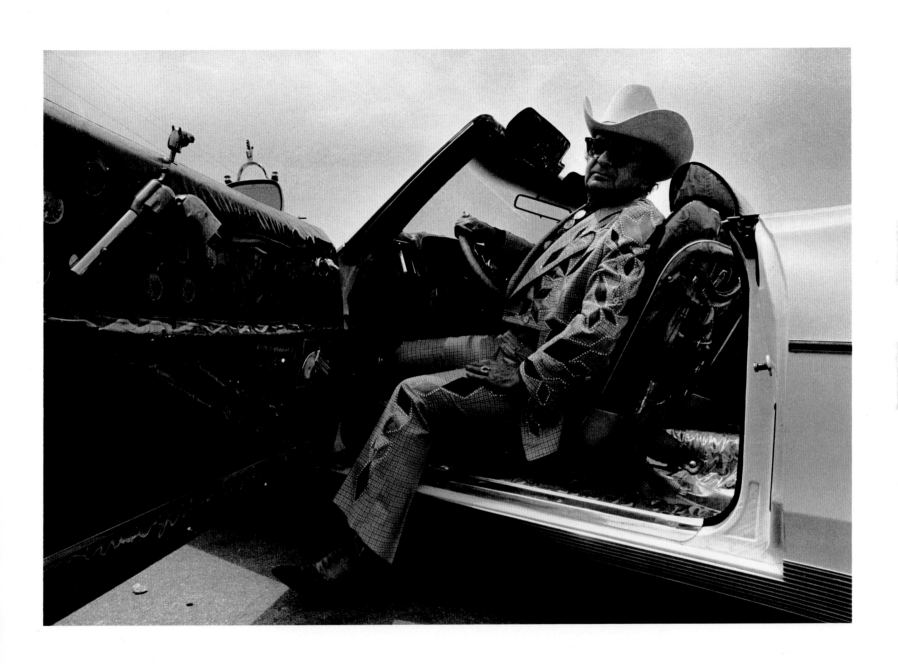

NUDIE *Rodeo Tailor to the Stars, North Hollywood, May 1969*

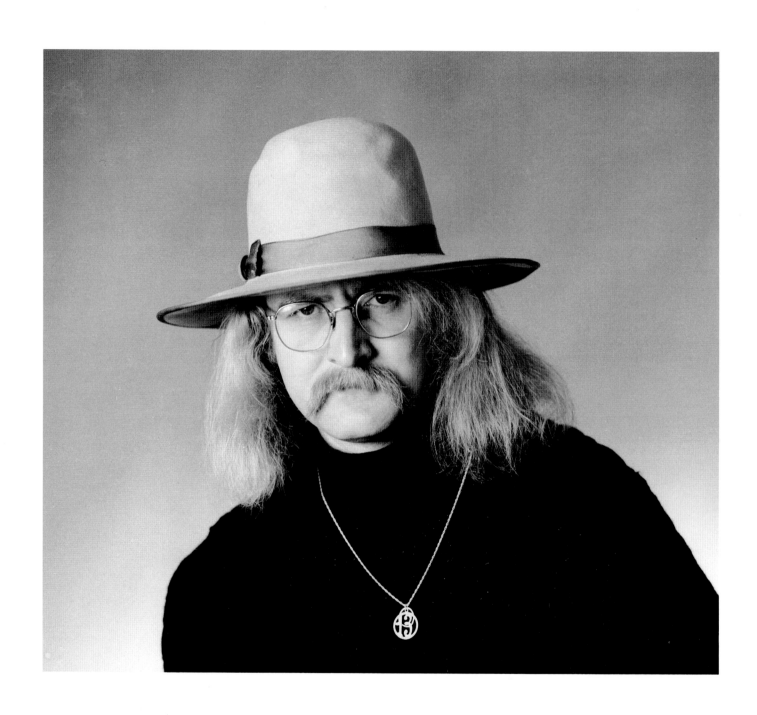

RICHARD BRAUTIGAN *Author, Belvedere St. studio, San Francisco, Nov 1968*

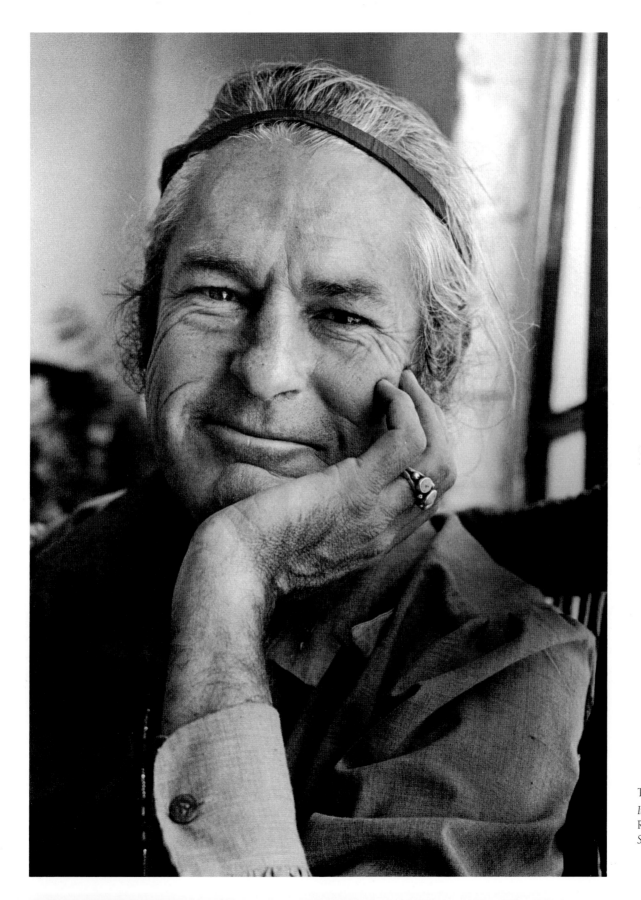

TIMOTHY LEARY
In the Brannan St.
Rolling Stone *offices*
San Francisco, May 1969

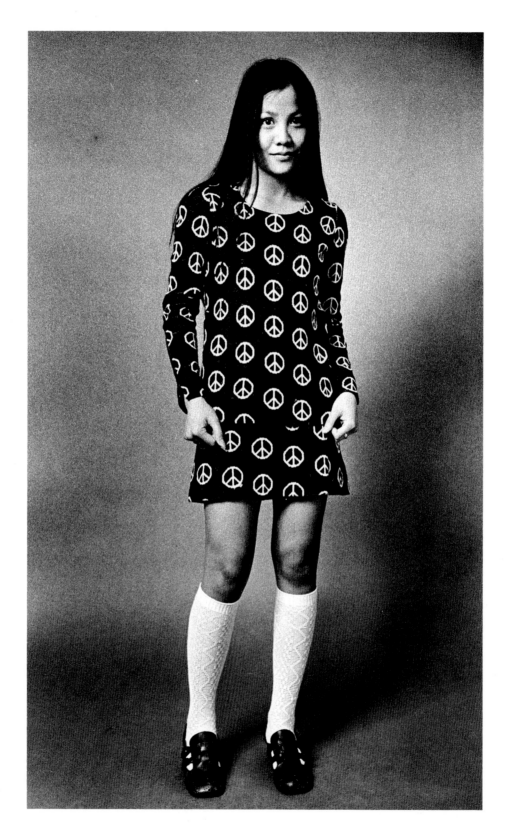

PEACE DRESS
by Alvin Duskin
Belvedere St. studio
San Francisco, Nov 1969

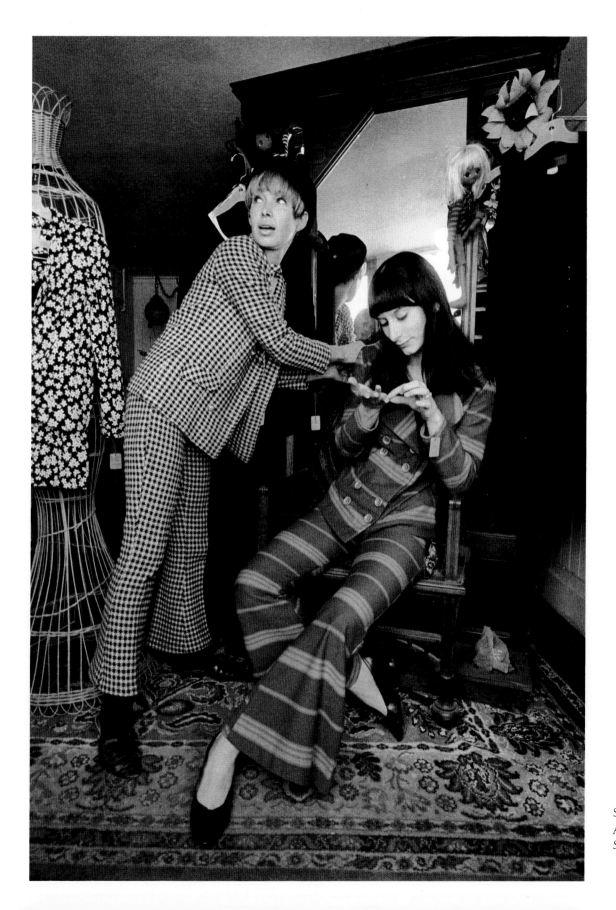

JANN WENNER *In original Brannan St.* Rolling Stone *offices, San Francisco, May 1969*

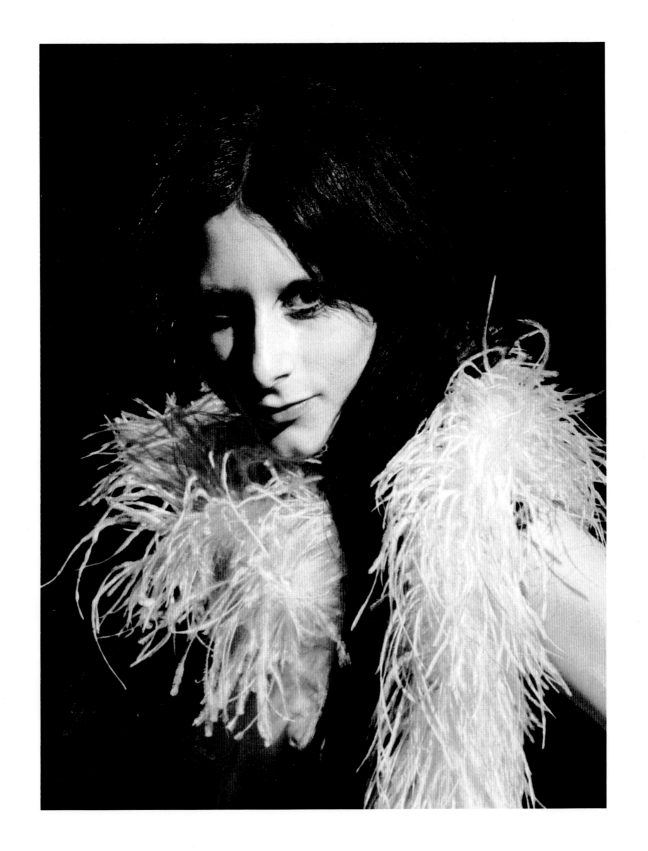

JULIANA *Cover of* Rolling Stone *Issue #11, Apr 1968*

No Regrets

OCCASIONALLY I wonder, "What if I had not left *Rolling Stone*? That road not taken, where would it have led?" The magazine enjoys enormous success; mine is more modest. But what if I had stayed? Would a career of shooting stars have lost its brightness over the years?

I was certainly not done with photography when I passed the baton of Chief Photographer to a young and gifted Annie Leibovitz. That event simply marked a turning point in my professional life.

I moved on mainly to roll the dice with a new magazine, *Rags*, the "*Rolling Stone* of fashion." If in music you could hear the sounds of change, in dress you could see it. At the time, the establishment fashion magazines, *Vogue* and *Harper's Bazaar* didn't recognize that a revolution of style was upon them, didn't understand that new ideas were accompanied by new clothes.

The *Rags* staff was creatively irreverent. For us, what people *were* wearing was more significant than what the magazines said they *should* wear. We went down on the street to hunt for true innovation in style.

We road-tested denim jeans, complained about unfair dress codes, and hammered the garment industry for its "fashion fascism." Our music critics included reviews of the clothes worn by the stars in their album cover photos.

We printed the magazine on newsprint, on the same presses that produced *Rolling Stone*, and even took over their original offices when Jann vacated Brannan Street.

Rags folded in 1971, and I moved out of the Haight, across the Golden Gate Bridge to Marin County. Trying to publish a magazine in a recessionary economy had been exhausting; I was running faster than my legs could carry me.

Yet, during the *Rolling Stone* and *Rags* years I had become a confirmed media junkie, addicted to the tingling glue-sniffing smell of printer's ink, delighted by transforming blank sheets of paper into visual treats. Still enthralled with guiding ideas to reality on the printed page, I found book publishing's leisurely production schedule much more attractive.

In 1974, Squarebooks was born. Since then we have produced editions about the Oakland Raiders, the Goodyear Blimp, the San Francisco and New York City fire departments, decorated denim, professional motor racing, homebuilt airplanes and custom vans. We have told the story of the building of the Golden Gate Bridge, published the poetry of a ninety-year-old retirement home resident, and with books and calendars, celebrated the beauty of California, Florida, Hawaii and Israel, each from the air.

When photographing the musicians, my goal had always been to let the soul of the artist shine through, and I accepted the fact that the success of even my best music photographs depended somewhat upon their star-content. Over time, however, it became increasingly important to me that the content itself be more personal, less dependent upon popular faces.

So, burned out on personalities, in the mid-Seventies I bought a little airplane, learned to fly, and began to look down upon our planet. I started making non-people pictures, aerial

landscapes, for I am dazzled by nature's ultimate perfection, intrigued by civilizations in motion, disturbed by an environment in danger, and worried about the ultimate effect of the hand of man upon the land.

These days I continue to make pictures, mostly from the window of my Cessna, and mostly in California. Squarebooks publishes them in the popular trademarked series of calendars and books called *California From The Air*.

In 1992, twenty-five years along the road toward that big darkroom in the sky, I sit here moving back and forth in random time. It's so confusing; where is reality? Before me lay these pictures from the Sixties: Jimi Hendrix, the Stones, Creedence Clearwater Revival. On the radio beside me the classic rock station plays the tunes of the Sixties; the Doors, Steve Miller, the Dead. Memories flood in; in a flash my mind jumps across time to the sounds, the sights, the smells. I am once more dancing with the camera, pursuing that elusive decisive moment.

Music continues to move me as only music can. And although I have no regrets about pointing my cameras elsewhere, there are musicians I would like to photograph, not necessarily on assignment, but simply because I am so drawn to them and their work. After all, expressing myself through pictures is what I did with love back then. Fortunately, it is still what I love to do today.

————

THANKS

So many to thank. So little space. The musicians for their talent and cooperation. Jann Wenner for his dream. Bill Graham for his chutzpah and vision. The words and pages of Rolling Stone *for memory jogs and occasional quotes. Bob Kingsbury, the* Rolling Stone *art director, for having used my pictures so well. George Hall and Jim Marshall for keeping me competitive. Michael Zagaris for reminding me how much fun we had. Chong Lee for endless contact sheets and prints and smiles.*

Kirk Anspach for the new enlargements. Ann Rhoney for her imaginative hand-coloring. Jack Jensen for encouraging me to keep this in the family; Candice Fuhrman for doing just that. Lauren Kahn for design, Christienne de Tournay for graphic support—and both for endless inspiration. Jim Hallock, Tom Oden and Caroline Sikes for excellence in edit. Ex-wife Juliana for her support and tolerance. My parents—both gone now—for making it possible in the first place...

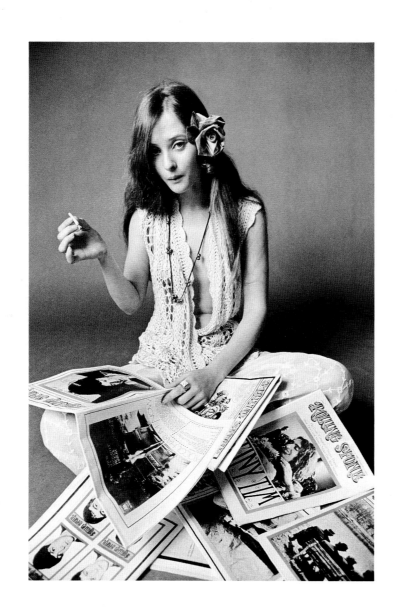